IMAGES
of America

SAN ANSELMO

To Madam Mayor about
whom at *least* a chapter
should be included in
the archives of San Anselmo.
Merry Christmas to the
Heart of San Anselmo.
With love & appreciation,
your devoted citizen,
Anne

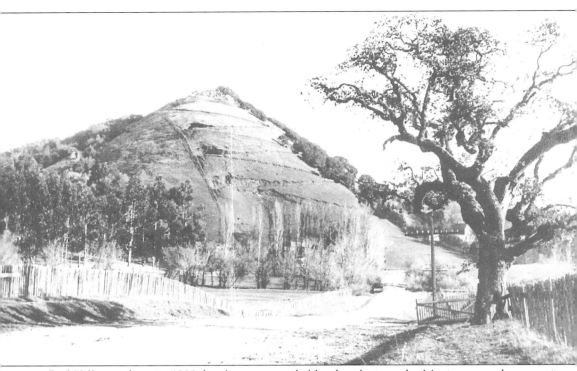

Red Hill, seen here in 1898, has been a recorded landmark since the Mexican era; the summit was the meeting point of three land grants. Rising 464 feet above "the Hub," it is San Anselmo's most recognizable geographic feature. The zigzag road up the western face, still visible today, was carved into the hillside by Chinese laborers in 1878 for Dr. Henry DuBois, who owned the land and the cemetery on the other side. Only two vehicles ever made it to the top. (Courtesy of the San Anselmo Historical Museum.)

ON THE COVER: The residents of San Anselmo crowd the railroad station platform on July 4, 1909, in wild anticipation of the grand parade about to pass by on the dusty road. The festivities for the Fourth of July were planned weeks in advance, and the streets were decked with flags, banners, and lanterns. Floats, decorated carriages and bicycles, mounted police, comical characters, and ladies on horseback added to the merriment and spirited celebration. (Courtesy of the San Anselmo Historical Museum.)

IMAGES
of America

SAN ANSELMO

Judy Coy and the
San Anselmo Historical Society

ARCADIA
PUBLISHING

Published by Arcadia Publishing
Charleston, South Carolina

Printed in the United States of America

Library of Congress Control Number: 2012941998

For all general information, please contact Arcadia Publishing:
Telephone 843-853-2070
Fax 843-853-0044
E-mail sales@arcadiapublishing.com
For customer service and orders:
Toll-Free 1-888-313-2665

Visit us on the Internet at www.arcadiapublishing.com

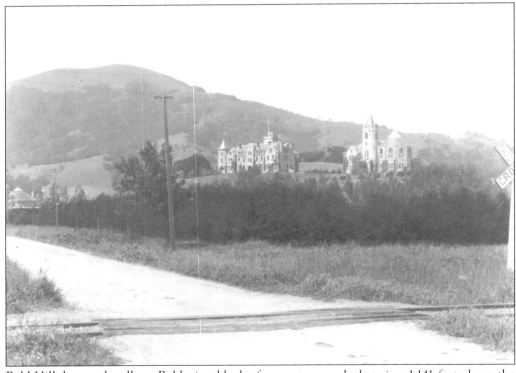

Bald Hill, known locally as Baldy, is a block of greenstone rock that rises 1,141 feet above the valley floor. This photograph was taken at Bolinas Avenue around 1900. The San Francisco Theological Seminary's Montgomery Hall (left) and Scott Hall sit on what was then a barren knoll. A natural spring on Bald Hill supplied water to George and Annie Worn's original ranch here and later to the seminary. The pipes and tanks were used during the drought in the 1970s to provide water for irrigation on the seminary's grounds.

CONTENTS

Acknowledgments

Since the Town of San Anselmo established the San Anselmo Historical Commission in 1976 for the purpose of preserving the town's history, many volunteers have contributed their time and expertise to make the town's historical heritage known to present-day residents. The San Anselmo Historical Museum, located in the town hall complex, is a testament to the hard work and dedication of many. I am indebted to those volunteers who conducted oral histories, collected and cataloged photographs, organized documents, and wrote explanatory text, and to those residents who donated family photographs and memorabilia. Other individuals, through their memberships in the nonprofit San Anselmo Historical Society, continue to provide critical financial support.

My great appreciation goes to Michelle Sargeant Kaufman of the Marin History Museum for allowing me to select photographs from the museum's rich collection to enhance the story of San Anselmo's history. Librarian Jocelyn Moss was also most helpful in locating and identifying materials for the book.

I am also indebted to Barry Spitz, who undertook the herculean task of writing the first comprehensive history of the area, *San Anselmo: A Pictorial History*, in 2001, which aided immensely in writing this book.

Librarian Laurie Thompson and digital archivist Carol Acquaviva of the Anne T. Kent California Room at Marin County Free Library were helpful as always in providing photographs and guiding my research. I thank the members of the San Anselmo Historical Commission for their encouragement along the way and Fred Codoni, Jeff Craemer, Marilyn Girodo, Charles Kennard, Dick Kientz, Dick Miner, Jack Mosher, Karen Peterson, Antone Sousa, Bill Sagar, and Richard Torney for their contributions and support.

Finally, I would like to thank the Town of San Anselmo for supporting the historical museum and recognizing the value of preserving the town's history for the benefit and enjoyment of future generations.

Unless otherwise credited, all images and archival material are from the collection of the San Anselmo Historical Museum.

INTRODUCTION

San Anselmo is situated in the heart of Marin County's Ross Valley. The spot that became downtown, with its major intersection, "the Hub," has long been a crossroads, if not a center, of activity. There is archeological evidence that the Coast Miwok lived in the area, hunted in the surrounding hills, and fished for steelhead and salmon in the fresh waters of San Anselmo Creek.

By the mid-1800s, the valley began to change when the Mexican government granted Domingo Sais property known as the Cañada de Herrera and gave John Rogers Cooper land known as Punta de Quintin, Corte de Madera, La Laguna y Cañada de San Anselmo, which was later purchased by James Ross. A third land grant, San Pedro, Santa Margarita, and Las Gallinas, was awarded to Timothy Murphy and included 200 acres within the borders of present-day San Anselmo. Deaths and legal disputes in the families of the grantees led to the breakup of the ranchos and the sale of land in the valley in the 1860s and 1870s.

San Anselmo remained pastoral until 1874, when the North Pacific Coast Railroad completed its line, first providing service between Sausalito and San Rafael and then offering a line west to Tomales and the Sonoma County timberlands. In the middle of it all was San Anselmo, the railroad's hub.

For the next decade, San Anselmo was simply known as Junction. By the 1890s, after taking its name from Cooper's original land grant, the area began to slowly grow. Railroad officials encouraged real estate activity along its line, and the Presbyterians moved their seminary from San Francisco to 14 acres in the Sunnyside Tract. Sunny San Anselmo, with sylvan campsites along the creek, also attracted many San Franciscans for a break from summer fog.

As San Anselmo grew, so did the need for public schools. The town's first official school, simply called San Anselmo School, opened in 1898. The town's second school opened in 1908 near the recently built Lansdale station. In 1900, the Presbyterian orphanage opened in an imposing three-story building on a knoll west of Red Hill. Destroyed twice by fire, the orphanage, funded by shipping magnate Robert Dollar, was rebuilt and became Sunny Hills in 1931.

In 1903, the narrow-gauge railroad was replaced with the third-rail electric train, and the trip from San Anselmo to San Francisco, via rail and ferry, took only 55 minutes. The small community changed dramatically in 1906, when the earthquake and fire drove families out of San Francisco and permanently into San Anselmo, which escaped the earthquake with only minor damage. Damage consisted mainly of fallen or cracked chimneys, and the clock tower of Scott Hall at the seminary collapsed into the roof.

With the influx of new residents, San Anselmans voted to incorporate in 1907. While the narrow 83-to-79 vote reflected debate on various issues, the most controversial was centered on the sale of liquor. Town residents had already succeeded in blocking applications for new liquor licenses. To get around the Prohibition, "blind pig" establishments surreptitiously served drinks in back rooms to known patrons. Pro-incorporation advocates pushed for an officially "dry" town, where liquor could only be sold for medicinal or industrial uses. They won, and persons selling liquor in the town limits could get at least 30 days in jail.

After incorporation, attention was focused on creating a true downtown center. When James Tunstead donated land in 1910 for a town hall, the commercial center started to form along San Anselmo Avenue. A new Mission-style train station was completed in 1912, and in 1914, San Anselmo received a $10,000 Carnegie grant for a library.

San Anselmo continued to grow after World War I and downtown expanded with the construction of two imposing bank buildings and new stores that flourished. Two new schools also opened: St. Anselm School in 1924 and Red Hill School (also known as Isabel Cook) in 1928. In 1924, the town purchased seven acres to build Recreation Park (later Memorial Park). The Log Cabin there, built in 1933 by the American Legion for the Boy Scouts of America, became a center of community activity, as did the baseball field.

The financial boom times ended in 1929 with the onset of the Great Depression. The first victim in San Anselmo was a plan to build a large resort hotel in Sleepy Hollow. The Sleepy Hollow Hotel would have included a lake and two golf courses. One of the courses was built, the Sleepy Hollow Golf Course, and opened in 1937. It closed after only four years but did not deter interest in developing Sleepy Hollow. Lang Realty started subdividing for single-family living in the valley.

In the busy decades following World War II, homes were built in new subdivisions and community services expanded in response to the influx of veterans with families. Changes to San Anselmo included the relocation and expansion of the post office, the addition of a town hall administrative wing, and the expansion of the library. Downtown got new streetlights in the early 1960s and Red Hill Shopping Center opened in 1967. New schools were built, including Lower Brookside, Sleepy Hollow, Hidden Valley, and Red Hill Middle School. In 1946, Main School was rebuilt and renamed Wade Thomas School in honor of the long-serving school district superintendent and principal. Sir Francis Drake High School opened in 1951 on farmland formerly owned by the Cordone family. In 1965, San Domenico School moved from San Rafael to Sleepy Hollow.

Unfortunately, the interurban train-ferry system did not survive. The opening of the Golden Gate Bridge in 1937 sealed the railroad's fate. Train ridership fell to one-half its 1930 volume. Despite protests by train lovers, rail commuter service in San Anselmo ended in 1941.

Several times in the past 100 years, heavy rains have turned the normally tranquil San Anselmo Creek into a raging waterway, creating havoc for businesses and homes in town. The creek flooded most recently on December 31, 2005, but the flood of 1982 stands as "the flood of record" and made sandbagging and installing floodgates an annual winter ritual.

The town's population peaked at around 12,000 in the 1960s, where it remains today. The town has remained true to its small-town heritage. Car repair shops still occupy buildings where blacksmiths and mechanics once practiced their trade. Consignment stores, antique shops, and restaurants thrive in the buildings where grocery and dry goods stores sold their wares. Sunny San Anselmo still attracts families and endeavors to maintain a small-town ambiance.

One

LAND GRANTS AND
EARLY SETTLERS

California became part of Mexico following its independence from Spain in 1821, and during the next 24 years, the Spanish missions were secularized and large land grants, or ranchos, were awarded to prominent Mexican citizens. Three men held title to grants within the boundaries of present-day San Anselmo: Domingo Sais, John Rogers Cooper, and Timothy Murphy.

Domingo Sais's 6,658-acre Cañada de Herrera rancho, awarded in 1839, encompassed the northwestern half of San Anselmo beginning at Red Hill and including Sleepy Hollow. Sais built San Anselmo's first structure, an adobe home on the hill above today's Sais Avenue. He died in 1853 without a will, and family legal disputes and sales of small portions of the land broke up the rancho.

The second land grant, of 8,877 acres, was awarded in 1840 to Englishman John Rogers Cooper. A sea captain, Cooper became a Mexican citizen, changed his name to Juan Bautista Cooper, and married a sister of Mexican general Mariano Vallejo. Cooper's Punta de Quintin, Corte de Madera, La Laguna y Cañada de San Anselmo ran southeast from Red Hill to Corte Madera and Point San Quentin. In 1852, Cooper sold his grant to Benjamin Buckelew, who in turn sold it to James Ross and Henry Cowell in 1857 for $50,000 in gold coin. James Ross became the sole owner that same year. Ross's death in 1862 led to the sale of large portions of his land. His son James Ross Jr. and daughter Annie S.E. Ross, who married George Austin Worn in 1863, settled in San Anselmo on the land they inherited.

Timothy Murphy was the third land grantee, claimant to San Pedro, Santa Margarita, and Las Gallinas, an immense 1844 grant that included 200 acres within San Anselmo north of Red Hill Avenue. Murphy's death in 1853 also triggered land sales and the breakup of his rancho.

In 1861, an open field in the Lansdale area was the site of California's last politically motivated duel. Former assemblymen Charles W. Piercy and Daniel Showalter squared off, with Piercy dying from a rifle wound.

By the late 1860s, new landowners settled in Ross Valley to join the Sais and Ross descendants. Minthorne Tompkins, William Barber, J.O.B. and Jacob Short, and James Tunstead were among the early settlers.

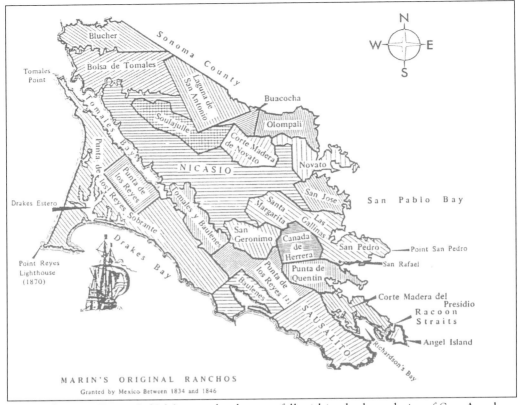

Three of Marin County's 21 Mexican land grants fell within the boundaries of San Anselmo: Rancho Cañada de Herrera; Rancho Punta de Quintin, Corte de Madera, La Laguna y Cañada de San Anselmo; and Rancho San Pedro, Santa Margarita, and Las Gallinas. The summit of Red Hill was the meeting point of the three land grants. (Courtesy of the Marin History Museum.)

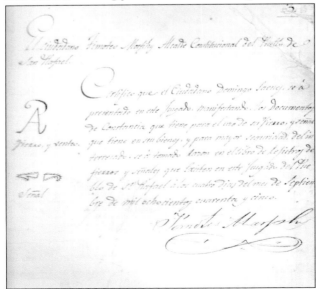

The *Book of Brands* is the earliest Marin County official record. On this page of the book, written in Spanish and bearing the signature of Timoteo Murphy as alcalde of the pueblo of San Rafael, Domingo Saenz (Sais) is granted permission to use the cattle brand shown in the margin. The document was recorded in the book on September 4, 1845. (Courtesy of the Marin History Museum.)

10

Marin County surveyor Hiram Austin prepared this map of the Cañada de Herrera in 1868. The map shows the division of the rancho among the heirs of Domingo Sais. G.W. Cozzens, related to the Sais family through marriage, sold his 574 acres to brothers John Orey Baptiste "J.O.B." Short and Jacob Short in 1868 for $21,113.

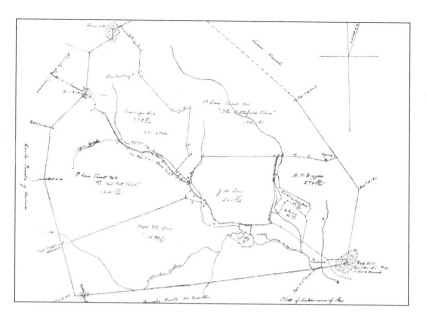

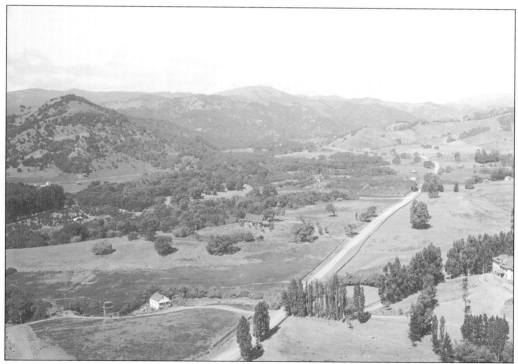

This 1900 panorama shows a portion of the Sais land grant, the 6,658-acre Cañada de Herrera, which encompassed the northwestern half of San Anselmo, including Sleepy Hollow. The Carrigan House, visible in the center of the photograph, was built in 1892 on the site where Domingo Sais constructed his first permanent home in the mid-1800s.

James Ross came to San Francisco in 1849 and made money in the wine and liquor trade. In 1857, he moved his wife, Annie Sophia Grayling, and their three children to the property he had recently purchased. He bought out his investment partner, James Cowell, to become sole owner of the Punta de Quintin land grant. When Ross died in 1862, Annie Ross was forced by the terms of James's will to sell large portions of the rancho.

James Ross, the eldest child of James and Annie Ross, was born in Tasmania in 1841 and moved to San Francisco with his mother and siblings to join his father in 1852. He married Mary Miller in 1865, and they built one of the finest homes in early San Anselmo on land he inherited. Ross was prominent in the Marin community and was serving a term on the board of supervisors at the time of his death at age 33.

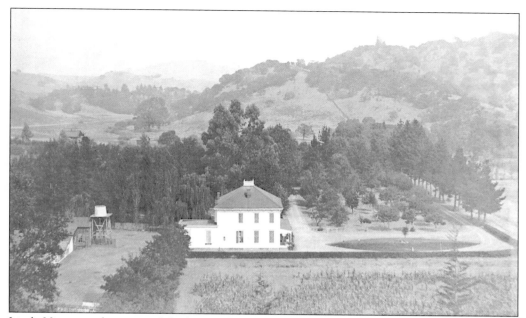

Linda Vista was the name of the home of James and Mary Ross. It was a lovely two-story wood-framed house on landscaped grounds about halfway up what is now Tunstead Avenue. This 1880s view looks east at Linda Vista with Pine Street on the right. The home was sold in 1912 and demolished in 1918.

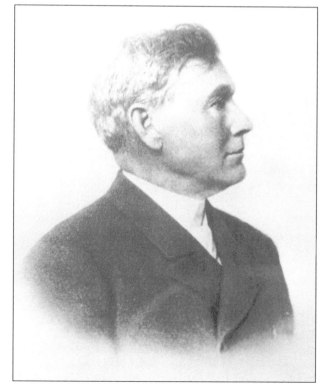

Mary Ross married James Tunstead in 1878, a few years after the death of James Ross. Tunstead, born in Ireland, came to Marin in 1866 and took up farming in Novato. In 1875, he was elected county sheriff and served until 1880. Shortly after their marriage, they leased Linda Vista and moved to a new home in San Anselmo.

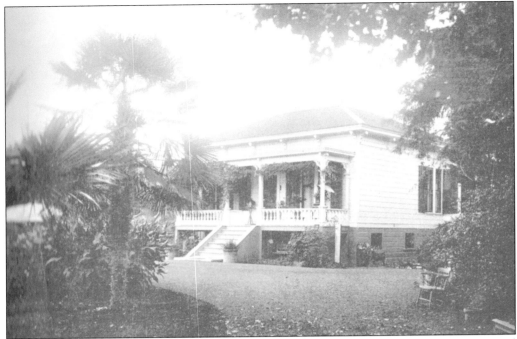

James and Mary Tunstead's second home in San Anselmo, Magnolia Cottage, was constructed in 1879 not far from Linda Vista. It was located near the creek at what is now Magnolia and San Anselmo Avenues with a large stable in the rear. In 1897, the home was turned into a hotel and the Tunsteads moved to a home above the Hub.

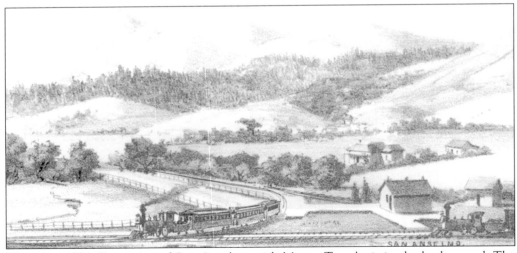

This is an 1884 illustration of San Anselmo with Mount Tamalpais in the background. The two trains are heading to San Rafael. The depot is in the right foreground with James and Mary Tunstead's Magnolia Cottage and stable behind. (Courtesy of the Anne T. Kent California Room, Marin County Free Library.)

14

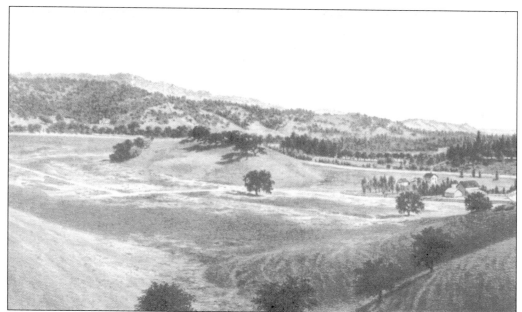

Annie S.E. Ross, the daughter of James and Annie Ross, married George Austin Worn. The Worns moved to their Sunnyside Ranch in 1881. The ranch house and outbuildings are on the far right in this artist's engraving. In the center is Richmond (Seminary) Hill, and visible across the valley is the home of William Barber, another early Ross Valley resident.

Minthorne Tompkins (1836–1920) was a San Francisco banker. He and his wife, Harriet, settled in San Anselmo in 1870 and raised six children. The children were educated by a teacher who lived with the family, as there were no schools in the area at the time.

15

The Tompkins purchased 45 acres east of Red Hill on Pine Hill and built their home in 1870. Their son Philip Tompkins was a chemist and photographer who took many fine early photographs of San Anselmo and the Ross Valley. Their daughter Ethel Tompkins founded the Marin Humane Society. Both Philip and Ethel lived their entire lives in the family home. Today, filmmaker George Lucas owns a portion of the original Tompkins property and homesite.

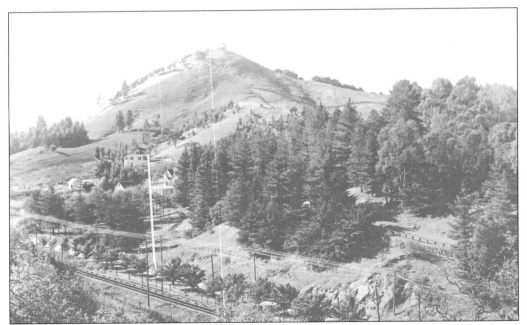

Timothy Murphy's land grant, San Pedro, Santa Margarita, and Las Gallinas, included the northern portion of Red Hill. The land was demarcated by the fence line running down from the top of the hill in this photograph from around 1910.

Two

TRAINS? IN SAN ANSELMO?

Today, it is hard to believe that the railroad played a significant role in the physical development of San Anselmo and in the lives of its residents for many years. The area was primarily pastoral, with only a few scattered homes until 1874, when the North Pacific Coast Railroad (NPC) completed its narrow-gauge line between Sausalito and San Rafael.

The following year, the line west to Point Reyes Station, Tomales, and the Sonoma County timberlands was completed. In the middle of it all was San Anselmo, the railroad's hub. It was simply called Junction until 1884, when the station was renamed San Anselmo, taking the name from John Rogers Cooper's original Mexican land grant. Passengers could reach San Francisco from Junction in under an hour.

In 1902, the NPC was purchased and became the North Shore Railroad. Tracks were converted to standard gauge, with trains powered by an electric third rail. This interurban train-ferry service provided transportation for commuters to San Francisco and spurred real estate development along the line. In 1907, the railroad was consolidated with other lines and reborn as the Northwestern Pacific Railroad (NWP).

During the electric era, San Anselmo maintained its prominence as a major junction. Southbound railcars entering San Anselmo from San Rafael and Manor were coupled at the Hub before heading down Ross Valley and south to Sausalito. Northbound trains uncoupled at San Anselmo, with San Rafael trains heading east and Manor trains traveling toward Fairfax along what is now Center Boulevard.

Lansdale Station was the first San Anselmo stop for southbound trains coming from Manor. After Lansdale Station, the train proceeded to Yolanda Station, downtown San Anselmo, and Bolinas Avenue before heading toward Sausalito with stops along the way. In the 1920s and 1930s, the railroad ran a "School Special" to and from Mill Valley's Tamalpais High School, picking up students throughout the Ross Valley.

Highway development in Marin in the 1920s and 1930s, along with the opening of the Golden Gate Bridge in 1937, brought an end to interurban train-ferry service. Train service ended in San Anselmo on the evening of February 28, 1941. Today, the only clues that railroads once ran through town are the neighborhood names of Yolanda Station and Lansdale Station and the raised roadbed of Center Boulevard.

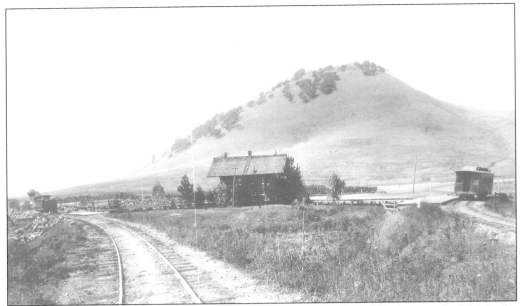

Red Hill rises above the lonely outpost known as Junction in this 1875 photograph. This is the first depot at the spot that would become San Anselmo. The North Pacific Coast Railroad tracks head to Fairfax, Point Reyes, Tomales, and the Sonoma County timberlands on the left and to San Rafael on the right.

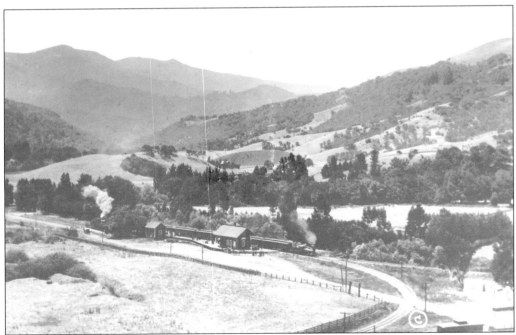

In 1884, the station was moved south by 100 yards and renamed San Anselmo. Richmond Hill, in the left center, is where the San Francisco Theological Seminary would begin building its campus in 1891.

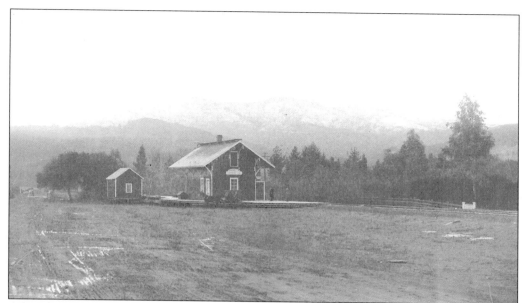

A lone horse and buggy waits at the depot on a chilly morning in this 1888 photograph. Mount Tamalpais rises in the background with a dusting of snow.

An eastbound steam locomotive huffs and puffs as it attacks the two-percent grade between San Anselmo and San Rafael's Highland Station in this 1880s photograph. A number of short local trains ran between San Anselmo and B Street in San Rafael during this decade. The horse and buggy also heads east on the San Rafael/Olema County Road.

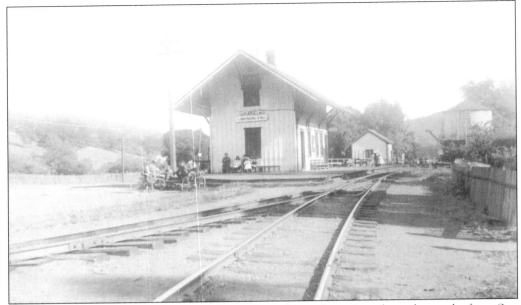

This 1898 trackside view of San Anselmo station shows the point where the tracks from San Rafael (right) meet those from Fairfax and points west. Water was drawn from the creek and stored in the water tower to replenish the steam engines. The base of the water tower was enclosed in 1909 to create the new town's first jail.

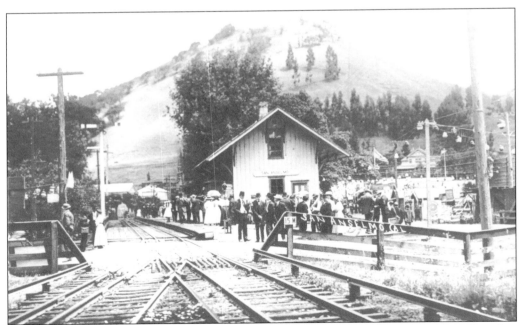

The railroad switched to electric operation in 1903, and the laying of broad-gauge track to San Anselmo began the same year. This 1907 photograph of the station shows the broad- and narrow-gauge tracks as well as the raised third rail, which provided electric power.

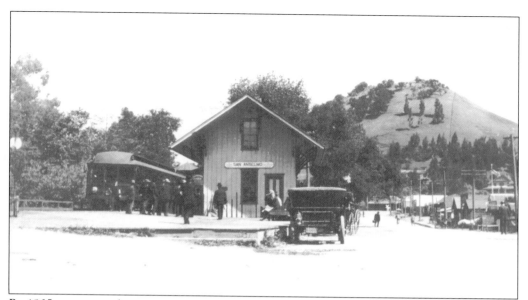

By 1905, numerous businesses were established in ramshackle buildings opposite the station along the county road. The zigzag road climbing the face of Red Hill was graded in 1893 by pioneer settler James Tunstead, and the site was offered for sale for a country home. (Courtesy of Antone Sousa.)

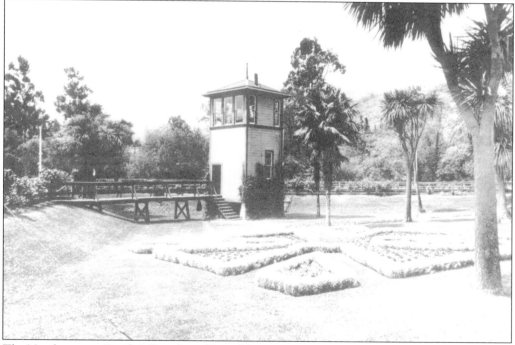

The Northwestern Pacific's Switching Tower No. 4 was constructed in San Anselmo in 1909. An operator in the tower controlled the switches and signals in the area and the interlocking system ensured safe movement of the trains through the junction. The Northwestern Pacific was noted for its elaborate gardens at each station.

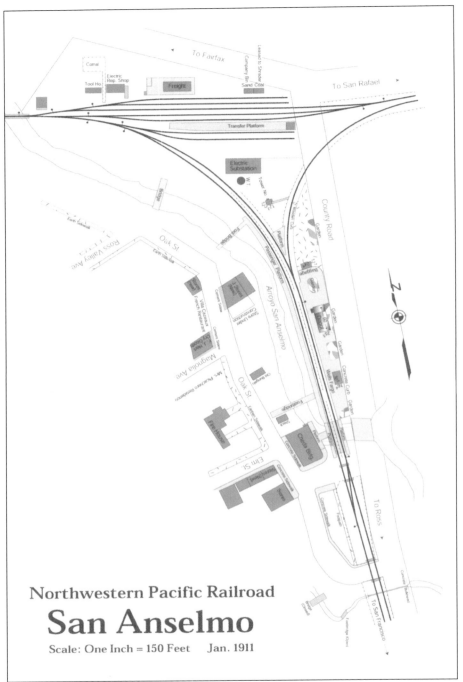

Northwestern Pacific Railroad
San Anselmo
Scale: One Inch = 150 Feet Jan. 1911

This map shows the layout of the San Anselmo station in January 1911. The Wells Fargo Express depot, the freight yard with its transfer platform and corral, electric power station, and numerous gardens are all identified. At the time the map was made, San Anselmo was the transfer station and the origin point for narrow-gauge freights for Point Reyes Station and other points on the line toward the Russian River. (Courtesy of the Northwestern Pacific Railroad Historical Society.)

This train had just passed Madrone Avenue on what is now Center Boulevard on its way west to Fairfax and Manor 1939. Sycamore Avenue is on the right. This section was double-tracked in the mid-1920s.

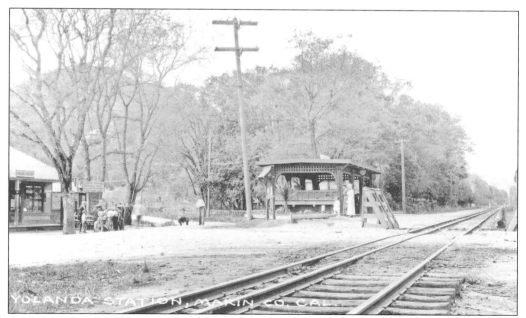

Yolanda Station was the first stop added within San Anselmo west of the downtown station, opening in 1905. Freight cars ran on the narrow-gauge rails and passenger cars ran on the broad rails. The NWP constructed attractive new shelters like this one at the stations in San Anselmo in 1913. The sign above the motorcycle on the left reads, "Summer Visitors Register Here So Your Friends Can Find You." This was a popular area for summer camping.

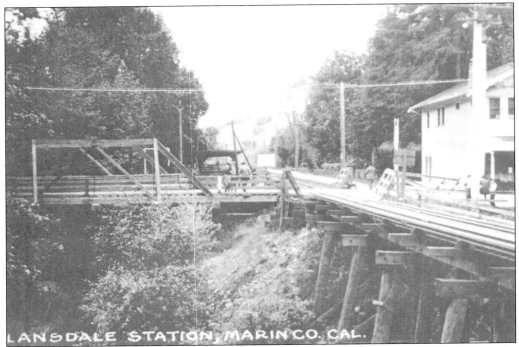

LANSDALE STATION, MARIN CO. CAL.

Lansdale Station, the westernmost stop within San Anselmo, opened in 1908. It was originally called Bush Station but was renamed for Philip Lansdale, a partner in the real estate firm that developed the surrounding area. The trestle carried the track over San Anselmo Creek. The building on the right was a grocery store in this 1918 photograph; a branch of the post office opened in the store in 1924.

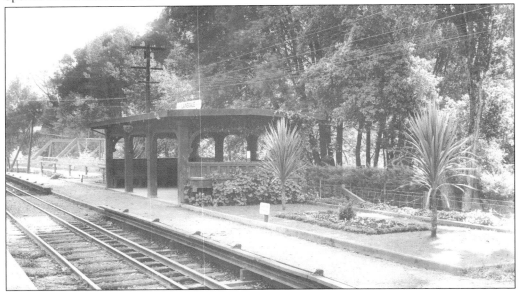

The Northwestern Pacific used a standard design for the shelters along the line. This one at Lansdale was similar to those at Yolanda, Bolinas, and Highland Stations. Each had an attractive garden with palm trees.

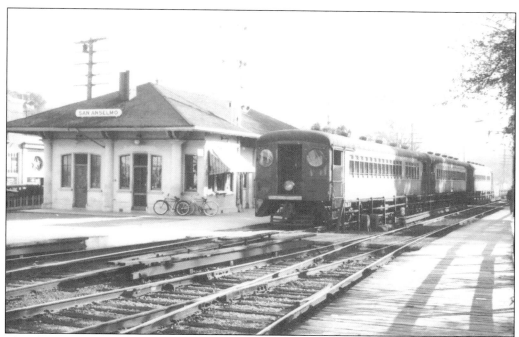

The old shed-like wooden depot had seen better days, and riders were tired of waiting in its drafty interior. In 1912, the NWP completed a new Mission-style depot just north of the one that had served the town since 1874. The ticket window under the canopy and an office were located at the north end (above). The commodious waiting room was at the southern end (below). Just beyond the station to the north was the baggage and express office. One *San Anselmo Herald* writer commented that the "old station looks like the kitchen to the big house." (Both, courtesy of the Marin History Museum.)

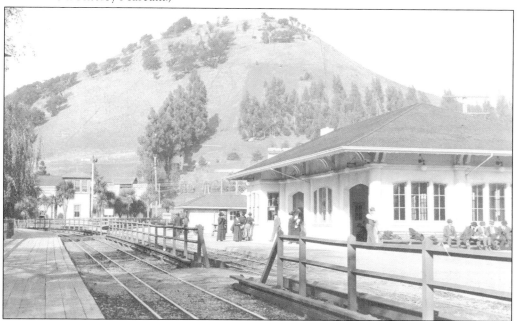

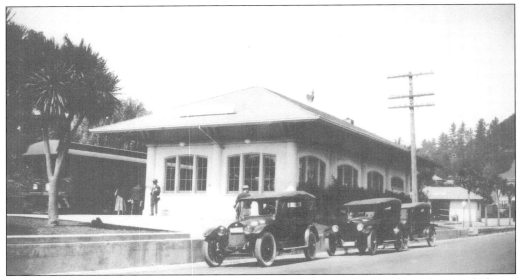

A 1913 schedule shows a 58-minute commute from San Anselmo to San Francisco, including a 32-minute ferry ride. The No. 413 departed San Anselmo at 6:37 a.m. and arrived in Sausalito at 7:00 a.m. There, commuters hopped on a ferry, which left Sausalito at 7:03 a.m. and docked in San Francisco at 7:35 a.m.

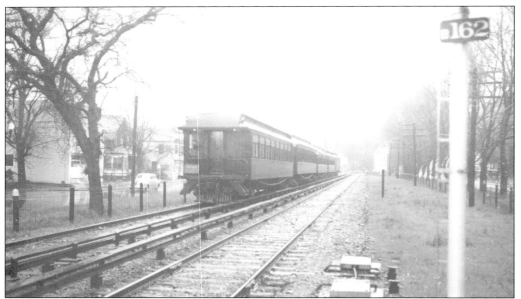

This train heads south from San Anselmo Station toward the next stop, Bolinas Station. San Anselmo Avenue at Mariposa Avenue is on the left, and Sir Francis Drake Boulevard is on the right. (Courtesy of the Marin History Museum.)

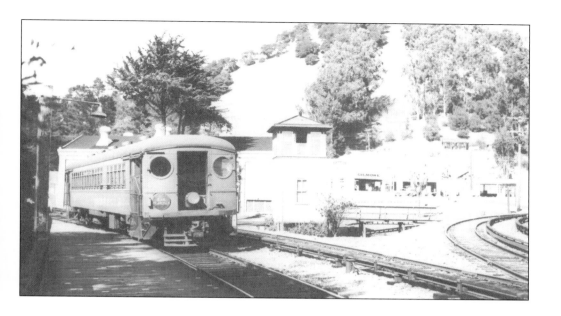

In 1929, the NWP purchased new steel cars that were pumpkin-orange in color. In these two images from 1939, cars approach the San Anselmo station. Above, a San Francisco–bound car from Manor has just passed the power station and switching tower and is pulling into the platform. The car approaching from San Rafael (below) would be automatically coupled to the Manor car before heading south. That week, the Tamalpais Theatre (right) was screening *Rose of Washington Square*, starring Tyrone Power and Alice Faye. (Both, courtesy of the Marin History Museum.)

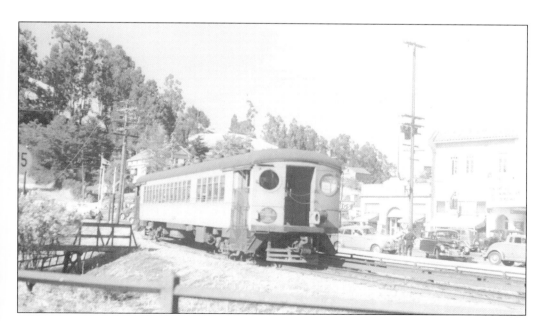

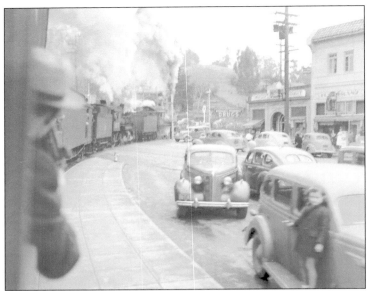

In the weeks before train service ended on the night of February 28, 1941, rail fans and railroad historical groups organized excursions over the Northwestern Pacific line. An old steam locomotive pulled several of the oldest wooden coaches while saddened passengers and spectators snapped photographs. This excursion train leaves San Anselmo on its way to San Rafael. (Courtesy of the Anne T. Kent California Room, Marin County Free Library.)

The tracks near the San Anselmo depot were removed and the baggage room was demolished within days of the rail service shutdown on February 28, 1941. Within a year, all the tracks had been removed, but it would take several more years before title to the railroad right-of-ways were cleared and they became part of the town's road network. The Bridge Street trestle and tracks along today's Center Boulevard were removed by the time this photograph was taken. (Courtesy of the Marin History Museum.)

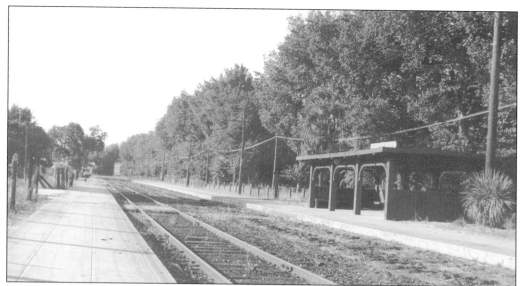

A station was added at Bolinas Avenue in 1912 after residents of the area petitioned the railroad company. This photograph was taken after rail service ended in 1941 and the tracks had been partially removed. The railroad bed eventually became the southbound lane of Sir Francis Drake Boulevard. (Courtesy of Fred Codoni.)

On Monday, March 1, 1941, Pacific Greyhound buses lined up at the station to take commuters on their first trip to San Francisco on the bus. To many residents, abandoning the railroad meant more than changing modes of transportation, it meant the end of a way of life. Greyhound provided the commuter bus service until the early 1970s, when the Golden Gate Transit District was formed. The power station and switching tower, still evident in this photograph, were demolished in 1960.

San Anselmo's depot was converted to a Greyhound bus station. It was demolished in 1963 so that Sir Francis Drake Boulevard could be widened to accommodate increased automobile traffic. The site of the power station and switching tower was turned into a parking lot before being transformed into Creek Park in 1974. All evidence of San Anselmo's railroad past had vanished at the Hub.

Three

SAN ANSELMO CREEK

San Anselmo Creek meanders through residential areas of town in a southeasterly direction from Fairfax. It is joined by the tributaries of Sleepy Hollow and Sorich Creeks before it enters downtown, where it turns and flows in a southerly direction toward Ross. At the confluence of Ross Creek, it becomes Corte Madera Creek and then winds its way to San Francisco Bay.

San Anselmo Creek has not always followed its current channel. Creeks have an inherent ability to adjust to landscape changes, and during a severe rainstorm in December 1867, San Anselmo Creek changed its course. Prior to that time, the channel ran along Laurel Avenue, winding in a southerly direction and crossing San Rafael, Tamalpais, and Magnolia Avenues, Tunstead Avenue (at mid-block), and Pine Street. Possibly a debris or logjam caused the creek to bend to the other side of what is now Center Boulevard.

In 1875, the North Pacific Coast Railroad completed its line through San Anselmo west to Tomales. The railroad, with its need for a straight and cost-efficient grade, built a berm four to five feet above the valley floor on which the tracks west from San Anselmo were laid. The berm narrowed the floodplain and caused the creek channel to become more deeply incised.

Before homes were built along the banks, the creek provided recreational opportunities. From the 1890s to the 1920s, San Francisco residents were drawn to the temperate climate for a break from summertime fog, and many chose to camp along the creek. Fish and wild blackberries were plentiful, and swimming holes were inviting.

Several times in the past 100 years, heavy rains have caused the normally calm and gentle San Anselmo Creek to overflow its banks and become a torrent of destruction, severely damaging businesses and homes in town. The flood of 1982 was "a flood of record." It made sandbagging and installing floodgates an annual winter ritual and spurred the town to reinstate the warning horn in the town hall tower—five blasts repeated three times is the call to arms.

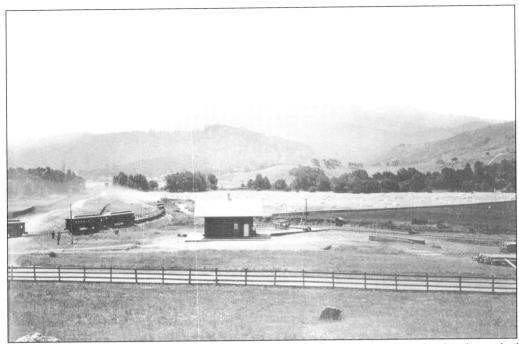

The mature riparian vegetation across the center of this 1875 photograph marks the channel of San Anselmo Creek prior to 1867. This old channel gradually filled in, and the raw gully-like channel of the modern-day creek is directly behind the depot, without riparian vegetation.

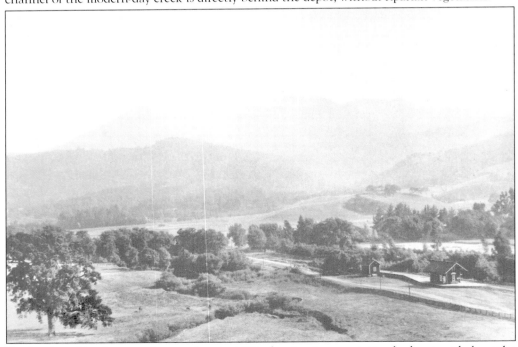

By the time this photograph was taken in 1886, the riparian vegetation had matured along the new channel of San Anselmo Creek, next to the railroad depot.

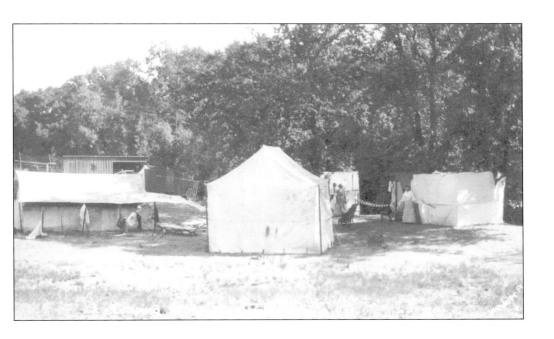

From the 1890s into the 1920s, many families came to San Anselmo to camp along the creek. Lincoln Park, east of Sir Francis Drake Boulevard, featured a dance floor and ball field. Bernard Brennfleck offered campsites, shown above and below, on his eight-acre nursery property along the creek in Yolanda Park. Water was piped to every camp. (Both, courtesy of Jim Staley.)

Camping in San Anselmo, Cal.

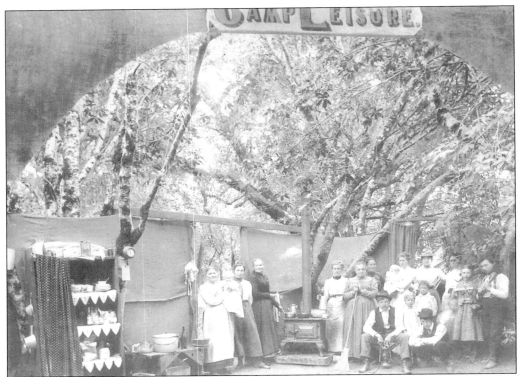

Family campsites in San Anselmo could be quite elaborate affairs, with raised platforms, striped canvas tents, hammocks, and paper lanterns. This campsite was outfitted with a cast-iron wood-burning stove. (Courtesy of the Marin History Museum.)

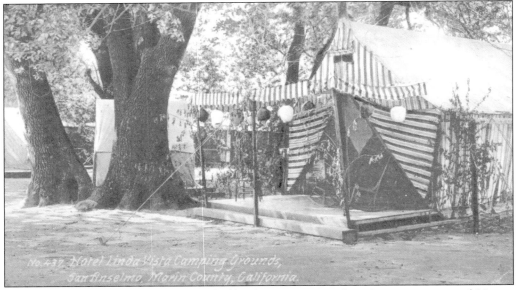

In the early 1900s, the Linda Vista Hotel offered camping grounds and rooms in a natural 20-acre park. It was located between Pine Street and Magnolia Avenue, bordering Cedar Avenue. There was a large dining room, a dance floor, and tennis courts.

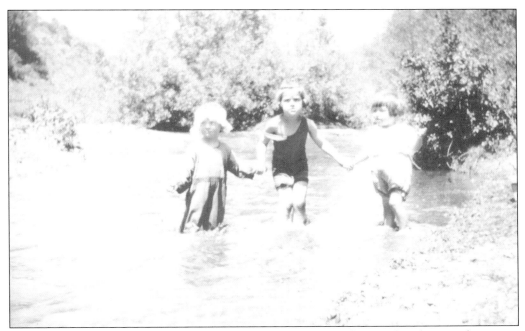

San Anselmo Creek was a summer playground for children and a popular place to play, swim, and explore. Here, from left to right, Bettie Flynn, Dorothy Sousa, and Lois Lawson frolic in the creek in the early 1920s.

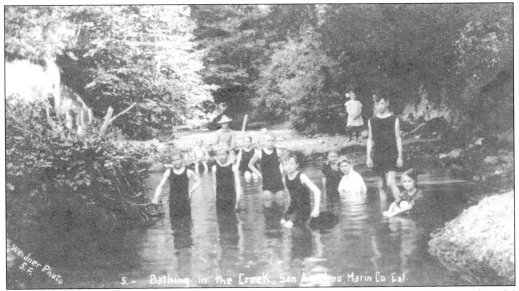

Youngsters enjoyed exploring the banks of San Anselmo Creek, and fish and crawfish were plentiful in its waters. In several places, the creek was dammed, creating inviting swimming holes. An overhanging branch provided a perfect place for a rope swing. (Courtesy of Jim Staley.)

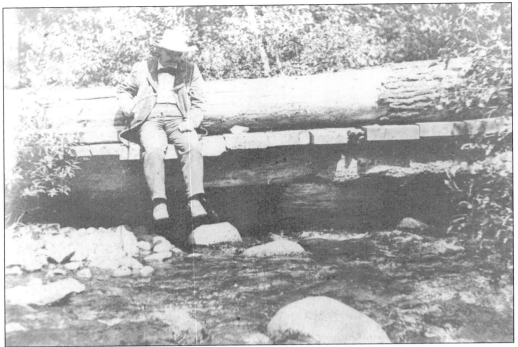

San Francisco attorney William Barber purchased property in Ross Valley in 1866. In his retirement, he took pleasure in fishing San Anselmo Creek, which flowed through his property. Steelhead trout and salmon were plentiful in the creek most years.

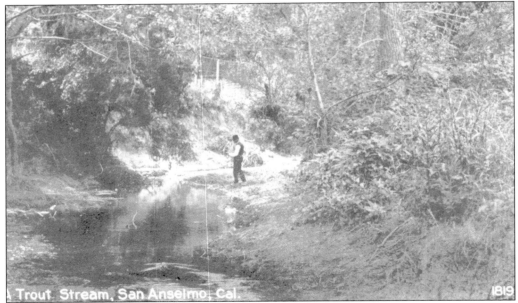

San Anselmo Creek attracted anglers from all over the Bay Area, and opening day of trout season was anxiously awaited. This postcard from around 1910 presents an idyllic scene along the creek. When the water was low and the fish congregated in shallow pools, they were easy catches for young boys.

Located next to the Hub, one of the busiest intersections in Marin County, and on the former site of a paved parking lot, Creek Park is a quiet oasis in the middle of downtown San Anselmo. The park, seen at right and below shortly after its completion in 1974, was designed by local architect Daniel Goltz. It was dedicated to "the principles of the American Revolution" on the occasion of the bicentennial of the American Revolution. Today, there are benches and picnic tables in the redwood grove off the main grassy knoll. Creek Park is the site of many local events, including "Music in the Park" and "Film Night in the Park."

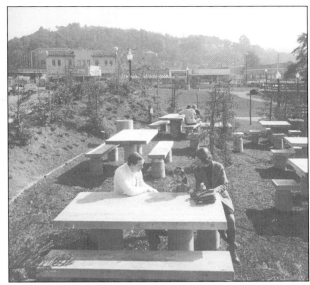

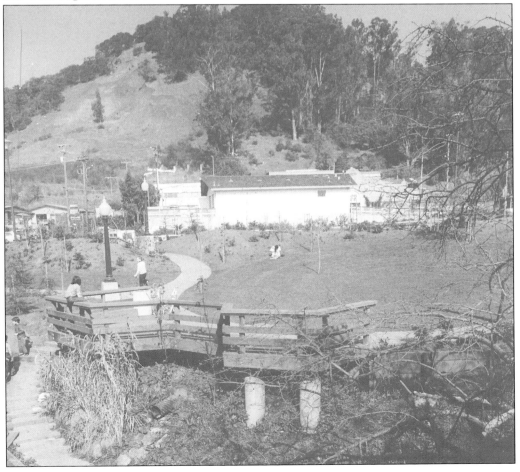

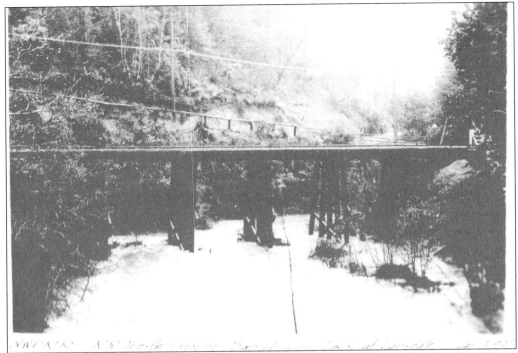

Heavy rains fell in January 1921, and the water ran high and fast as it passed under the railroad trestle at Lansdale. Culverts and drains in various parts of town backed up, and there was flooding in basements downtown. Lower San Anselmo Avenue looked like a river.

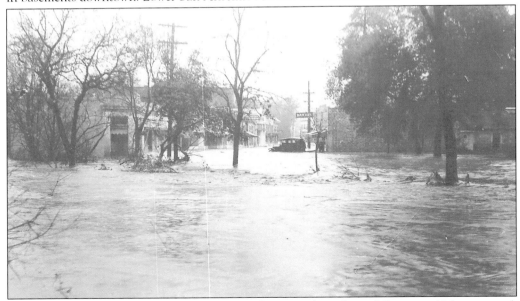

Heavy rains hit town on February 10, 1925, with 6.77 inches of rain falling in a 12-hour period. The alarm was sounded by the fire chief, who notified merchants within reach that the water was rising. The creek overflowed its banks and flooded the streets in the center of town as storekeepers scrambled madly to find dry spots to pile merchandise.

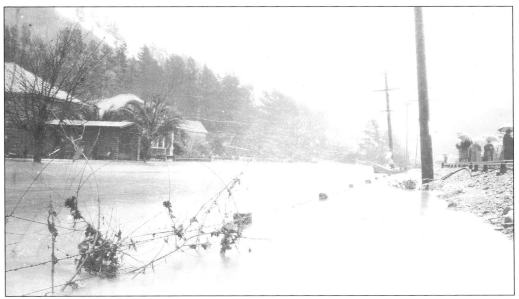

The North Pacific Coast Railroad wisely constructed a berm about five feet above the valley floor and laid the tracks west from San Anselmo on it. This photograph shows flooded Sycamore Avenue on the left with a crowd gathered trackside during the 1925 flood.

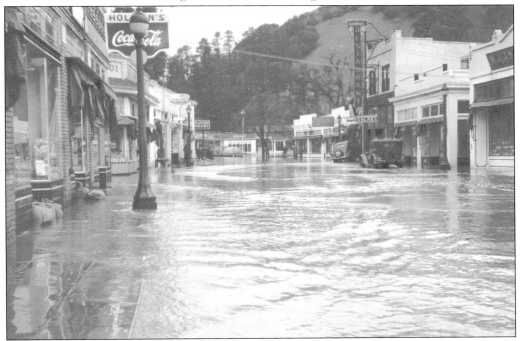

On January 20, 1943, nine inches of rain fell in a 24-hour period and the creek went over its banks at Bridge Street, flooding the downtown business district. There was a raging torrent between one and two feet deep along San Anselmo Avenue. Merchants removed sandbags that had been placed around the library at the beginning of World War II as bomb protection and used them to block floodwaters from entering their places of business.

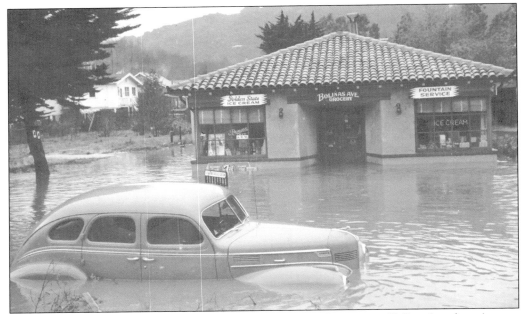

Sandbagging did not seem to work for the Bolinas Avenue Grocery, at 29 San Anselmo Avenue on the southern end of town, in the flood of January 20, 1943. This automobile did not fare well either. At the time of the photograph, Jewel and Freemont Simpson ran the grocery. Longtime residents remember the grocery stores that followed: Bill's Cash & Carry in the late 1940s and early 1950s and Bing Fong's Panama Market into the mid-1960s.

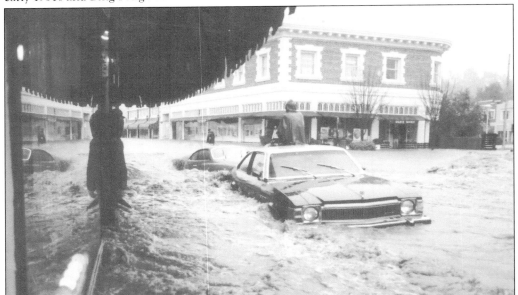

Heavy rains fell in the last two weeks of December 1981 and again on January 3 and 4, 1982. By noon on January 4, San Anselmo Creek had overflowed its banks and carved a course through downtown San Anselmo. A river five feet deep swept down San Anselmo Avenue, inundating cars and flooding businesses. As the water rose inside businesses, windows exploded, spilling goods into the torrent. Damage to downtown businesses was estimated at more than $4 million.

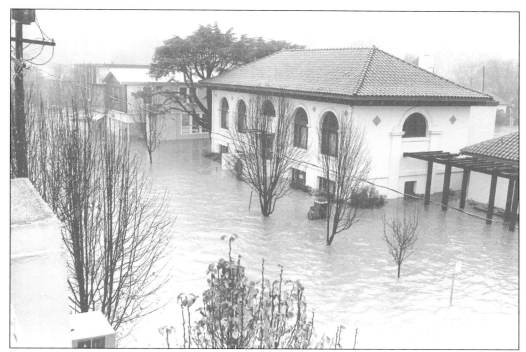

The flood of 1982 severely damaged the San Anselmo Library. There was five feet of water and mud in the basement and over 1,000 books were destroyed. Some of the damaged materials were sent to San Francisco to be freeze-dried, including the master inventory of books. Waterlogged magazines were hung on clotheslines to dry by more than 40 volunteers, who worked for more than a week.

As the floodwaters of January 4, 1982, receded, the San Anselmo Avenue business district was left with mud and devastation. But a spirit of cooperation prevailed in town and volunteers turned out to help merchants shovel mud and clean out damaged goods and soggy carpets.

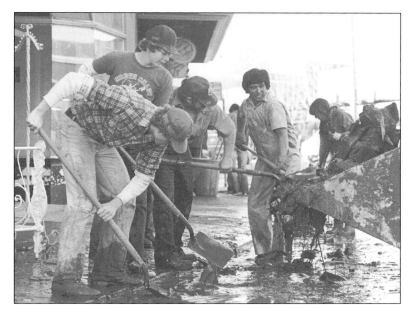

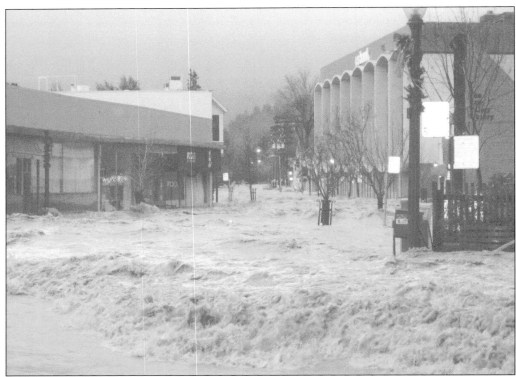

Town residents thought such a devastating flood could not happen again. However, in December 2005, the wettest December in 50 years, San Anselmo Creek overflowed its banks in the darkness of the early-morning hours of December 31. Town facilities were damaged, including the library, police department, council chambers, and fire department, as well as 140 businesses and 290 homes. The photograph above looks south on San Anselmo Avenue from Pine Street while the image below shows San Anselmo Avenue to the north, with the light still burning at the Wells Fargo Bank ATM.

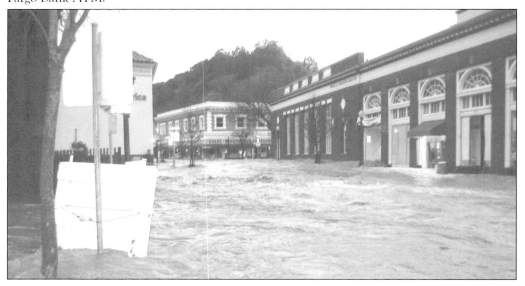

Four

SAN FRANCISCO
THEOLOGICAL SEMINARY

The San Francisco Theological Seminary was founded in 1871 in San Francisco under the guidance of Dr. William Anderson Scott. In the 1880s, the seminary began to look for a site for a larger campus. Arthur Crosby, the pastor at the Presbyterian church in San Rafael, encouraged the board of directors to consider Marin County for the new site, where he thought the climate was healthy and there would be room for the faculty to live on campus.

Since the seminary lacked the funds to purchase or build, it was a happy event when Arthur Foster of San Rafael, the president of the San Francisco & North Pacific Railroad and the son-in-law of Dr. Scott, bought land in San Anselmo at auction and donated 14 acres to the seminary on what was then called Richmond Hill.

San Francisco financier Alexander Montgomery's generous contribution of $250,000 in 1889 and another $10,000 in 1891 enabled the seminary to begin development of the San Anselmo campus with the construction of Montgomery and Scott Halls and faculty houses. Montgomery was one of the seminary's most important benefactors, even though he was not a Presbyterian, except through his Scottish ancestry, or a religious man. John Wright, a noted architect of the day, was hired to design the new buildings.

The dedication was held in September 1892, and the campus opened with six faculty members and about 20 students. Major growth came to the campus in the years following World War II. A renewed interest in religion led to an increase in faculty and students, and major capital construction projects were undertaken, including Geneva Hall.

The seminary's move to San Anselmo in 1891 led to a gradual change in the rural area around it, especially when the faculty homes were built and occupied. San Anselmo was likely destined for a growth spurt for other reasons around that time, but the seminary was a strong and conservative element that influenced the town for many of its early years. The San Francisco Theological Seminary has been a strong partner to the Town of San Anselmo throughout the years. The stunning buildings are architecturally and historically significant and are town landmarks.

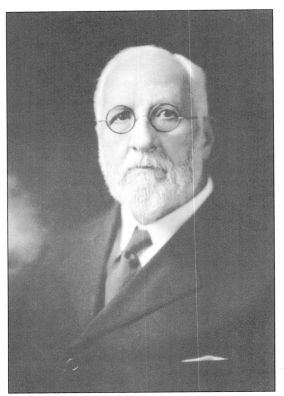

Arthur William Foster was born in 1850 in Ireland and came to San Francisco in 1875. He was involved in many business enterprises, including real estate, commercial agriculture, and banking. He was president of the San Francisco & North Pacific Railroad Company and became a regent of the University of California. Among his many philanthropic contributions was his donation of land in San Anselmo for the San Francisco Theological Seminary to build its new campus in 1891. (Courtesy of the San Francisco Theological Seminary.)

Seminary benefactor Alexander Montgomery was born in 1825 in Northern Ireland. He apprenticed as a tailor, a trade he pursued when he arrived in New York in 1846. But the news of the gold discovery lured him to California in 1849. Unsuccessful at mining, Montgomery found his calling in lending money to farmers in Colusa and Tehama Counties. By the time he opened an office in San Francisco in the early 1880s, he was a very wealthy man.

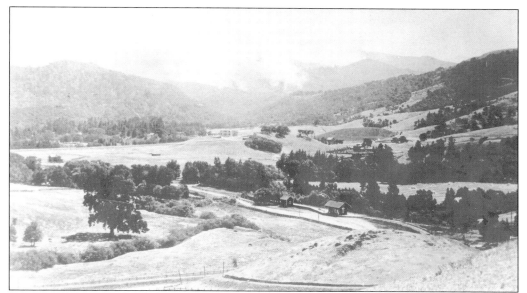

Grading for the new campus of the San Francisco Theological Seminary commenced in September 1890. The cornerstone for Montgomery Hall was laid on May 1, 1891, and construction began. This photograph was taken two months later, when a major fire burned out of control on Mount Tamalpais.

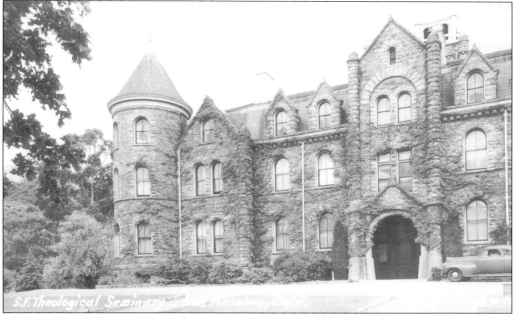

Montgomery Hall was dedicated in 1892. It was built of bluestone quarried in San Rafael. Stonemasons cut and laid the stones by hand. The builders were William Barr of San Rafael and J. McKay of San Francisco, and it was designed in the Richardsonian Romanesque style by the San Francisco architectural firm of Wright and Sanders. Originally used for student living quarters, each room had a fireplace for heating and students had to carry their own coal up from the basement.

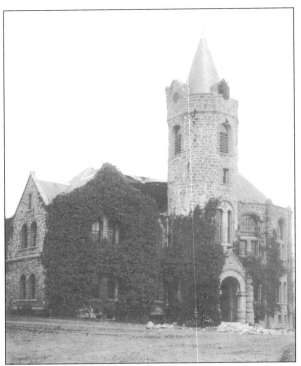

Scott Hall originally had the library and classrooms. It was built at the same time and with the same materials as Montgomery Hall. Just inside the entry is a circular staircase leading to the second floor, where a catwalk encircles the round room. It also had a turret tower with clocks on each side. During the earthquake of April 18, 1906, a part of the tower collapsed, and rubble can still be seen on the ground in this photograph.

When the 1906 earthquake rattled the area, the Bouick family ran from their nearby farmhouse just in time to hear the crash as part of the Scott Hall tower fell through the glass-domed library, through the assembly hall, and into the basement two floors beneath. The tower was rebuilt on a smaller scale, without clocks, as seen here. Both Montgomery and Scott Halls were restored and made seismically safe in the late 1990s.

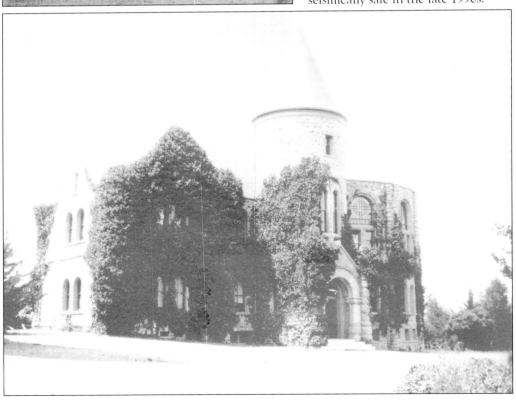

As seminary benefactor Alexander Montgomery lay dying, he donated $50,000 for the construction and maintenance of this Romanesque-style memorial chapel. The cornerstone was laid in 1894. When Montgomery died, he was buried at Laurel Hill Cemetery in San Francisco, but his remains were moved to Montgomery Chapel just days before its 1897 dedication.

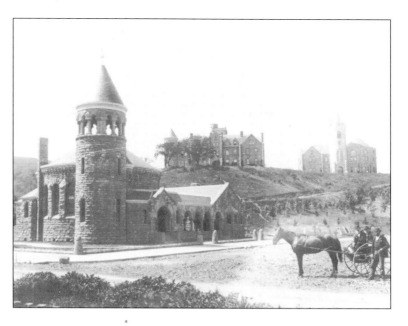

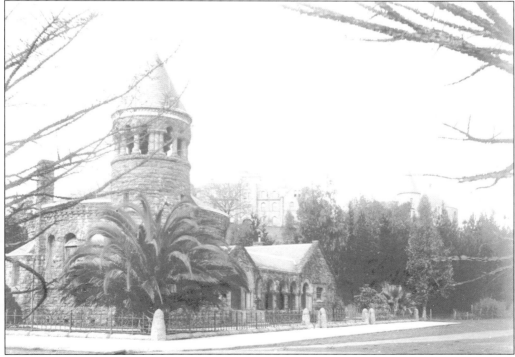

Montgomery Chapel was designed by the San Francisco architectural firm of Wright and Sanders. Alexander Montgomery's crypt is in an alcove to the left of the entrance to the circular sanctuary. A life-size marble bust of Montgomery is mounted there. John Wright's masterful design incorporated a private mausoleum within a Presbyterian chapel. The interior has no Christian images but is rich in Masonic ones. The beautiful stained-glass windows depict passages from the Old Testament.

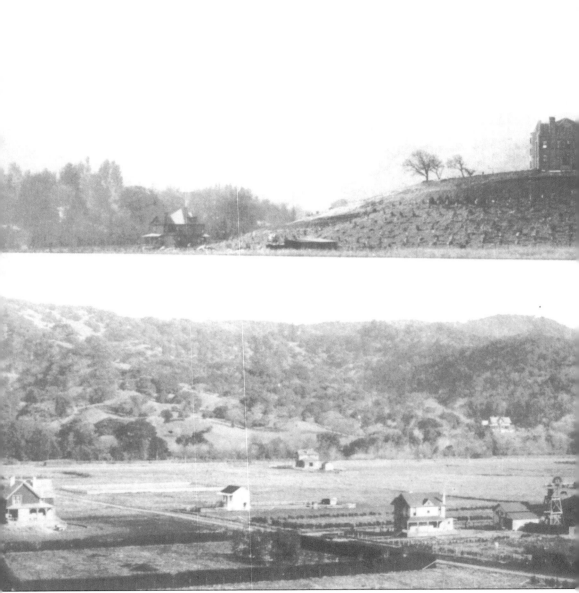

This double panorama shows the recently completed seminary halls on Richmond Hill in 1895. At top, Montgomery (left) and Scott Halls rise above newly planted trees on the hillside. The slopes of Bald Hill are on the right. The photograph at bottom was taken from Bald Hill and shows the sparsely populated area surrounding the seminary. Ross Avenue is on the left. The

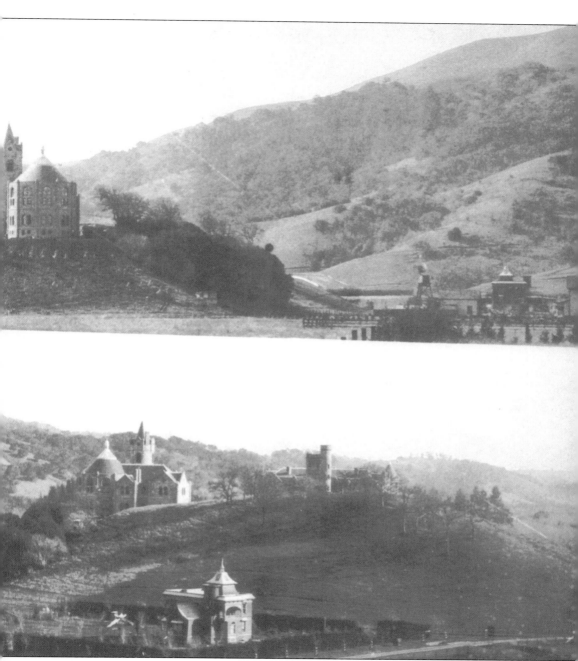

large Victorian mansion in the lower right belonged to James Wells Foss, a wealthy, retired, and reclusive bachelor. The home on the far left belonged to attorney Edward Crisp and his wife, Eliza. The hillside across the valley was on land owned by William Barber.

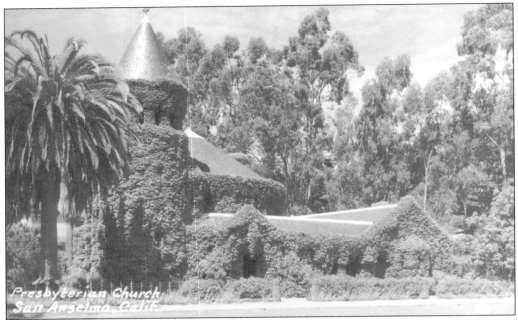

Montgomery Chapel, seen here in the 1920s enveloped in vines, served as the sanctuary for the congregation of San Anselmo's First Presbyterian Church from 1897 until 1950, when a new sanctuary was completed. The chapel has also been used by Greek Orthodox and Jewish congregations.

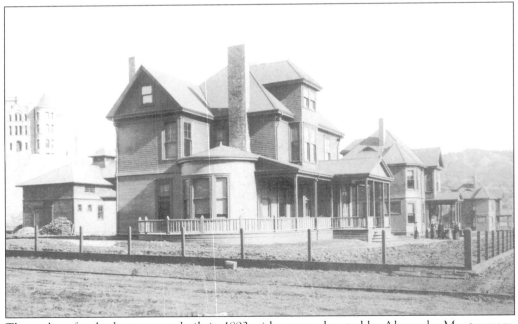

The earliest faculty homes were built in 1892 with money donated by Alexander Montgomery. Two of them, at 138 and 134 Bolinas Avenue, are still in use today. The third was demolished in the 1950s.

When the seminary moved to San Anselmo in 1892, this farmhouse became the home of Alexander Bouick, the groundskeeper of the seminary for 30 years. Bouick was much loved by the students, who would practice their sermons on him. They called him the "Doctor of Dust and Ashes." The members of the Bouick family are, from left to right, Alexander, his daughters Ethel and Mabel, and his wife, Jane.

In 1890, Thomas Day was hired by the San Francisco Theological Seminary as an instructor in Hebrew and Greek Exegesis. His family lived in one of the faculty houses on Bolinas Avenue and his children attended local schools. His family included, from left to right, (first row) Thomas and Clarence Day; (second row) Edward and George Day, unidentified, Ada Kingsbury Day, an unidentified man and child, and Isabelle Day. Thomas Day resigned from his faculty position in 1912.

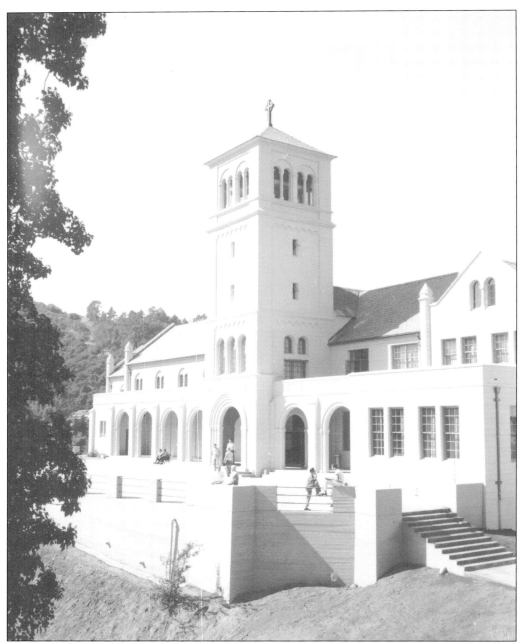

Geneva Hall, inspired by the Basilica of St. Francis in Assisi, Italy, was constructed in 1952. The architects were Winsor Soule and John F. Murphy of Santa Barbara. The hall includes Stewart Chapel, with stained-glass windows depicting the history of the Presbyterian Church in the west. The bells in the tower were donated to the seminary in 1923 by Robert Dollar. Each bell is inscribed with scriptures from the Bible. (Courtesy of the Marin History Museum.)

Five

TOWN SERVICES
AND SAFETY

The combination of reliable electric trains and the 1906 earthquake spurred development in San Anselmo. In the wake of the earthquake, new subdivision maps were drawn and a real estate row formed across from the railroad station. After the population grew from a mere 161 in 1900 to 985 in January 1907, talk turned to incorporation.

There were three issues surrounding the incorporation of the town: the threat of annexation from San Rafael, taxes, and the control of alcohol sales. Spirited arguments were presented by both sides in the incorporation debate. Those against argued that the tax rate would increase to support the new town government, saloons would be granted licenses, and poolrooms would be allowed. Proponents argued that ordinances would be put in place to prohibit saloons and poolrooms and that good roads and streetlights would be provided.

The vote was very close: 83 for and 79 against. Absent among the voters were the women of the community, since women were not allowed to vote in California until the election of 1912. The new town leaders immediately set to work adopting ordinances, forming a volunteer fire department, and appointing a town marshal.

In August 1910, the town accepted James Tunstead's donation of land on which to build a town hall and firehouse. The San Anselmo Women's Improvement Club was instrumental in obtaining a Carnegie grant for the construction of the library in 1915.

San Anselmo's population increased dramatically after World War II, and in the 1950s, an administrative wing was added to the town hall to conduct the growing town business. The first woman, Carmel Booth, was elected to the town council in 1948 and became mayor in 1950.

In 1978–1979, the town hall complex underwent a major remodel. The fire department moved to new quarters, the administrative wing and old fire department were demolished, and a new two-story building was constructed for administrative offices. The council chambers and tower remained in their original locations. The ground-floor council chambers and police department faced major repair work again in 2007 following the flood of 2005. The Town of San Anselmo celebrated its centennial in 2007.

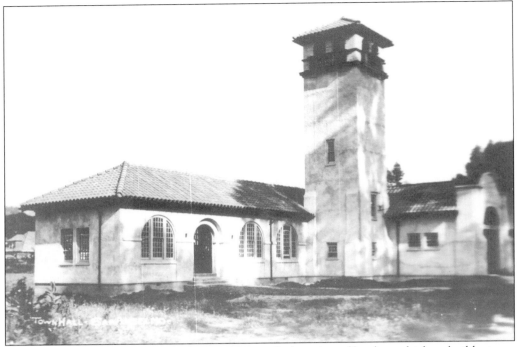

In August 1910, the town accepted James Tunstead's donation of land on which to build a town hall and firehouse. The Mission-style building, with a lofty bell tower, was completed and ready for business in June 1911. It is shown here shortly after construction. The architect was W. Garden Mitchell, a San Anselmo resident, and it cost $5,291 to build.

Juanita Lawson poses in front of the newly completed town hall and firehouse in 1911. The town purchased a pair of trained white fire horses for $500 to pull the fire wagon. One of them stands in the doorway of the firehouse ready for duty.

W. Ernest Jones, San Anselmo's first mayor, was elected at the first meeting of the board of trustees—as the town council was called then—in April 1907 and served as trustee and chairman until 1912. Jones and his wife, Mabel, had a summer home in San Anselmo and moved permanently to the Barber Tract after the 1906 earthquake. He was born in Contra Costa County to Welsh immigrant parents and owned a drayage company in San Francisco.

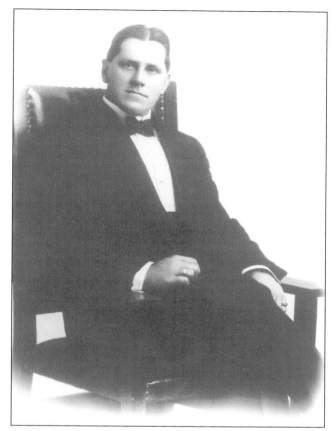

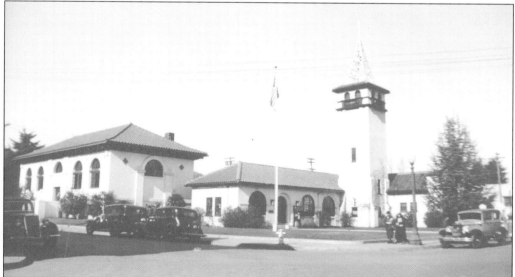

A support structure was built on the town hall tower for an antenna for emergency radio communication in the 1930s. The antenna allowed the drivers of the two radio-equipped police cars and the fire chief's automobile to converse with the operator at town hall.

55

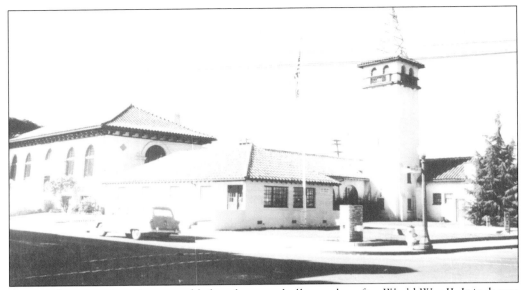

A new administrative wing was added to the town hall complex after World War II. It is shown here directly behind the flagpole. In 1955, the corporate name of the town was changed to the "City of San Anselmo." In 1975, residents petitioned the town council to change the name from "city" back to "town," in keeping with the character of the community.

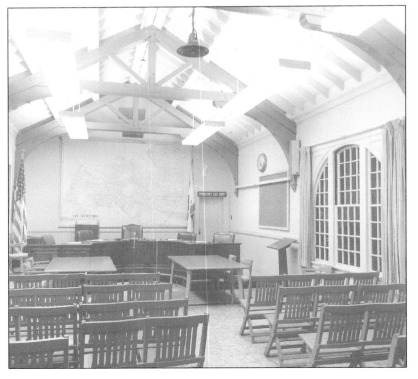

This photograph of the town council chambers was taken just prior to a 1978 remodel. The room was remodeled again after the flood of December 31, 2005. The original 1911 interior details, wainscoting, and windows were preserved but the spartan furniture was replaced.

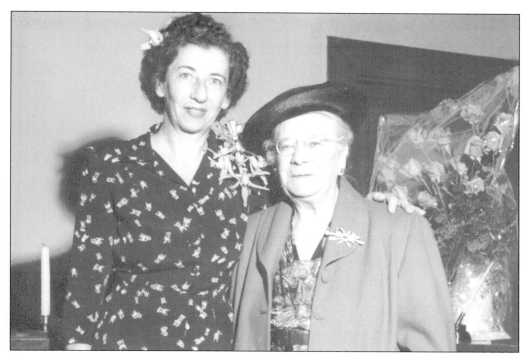

Carmel Booth, seen here with her mother, Nora Kasser, was the first woman to serve on the town council. She was elected to the council in 1948 and then elected mayor in 1950 and 1951. Booth's tenure on the council was often stormy, as some found her emotional and outspoken while others found her warm and passionate in her convictions. She resigned in July 1960.

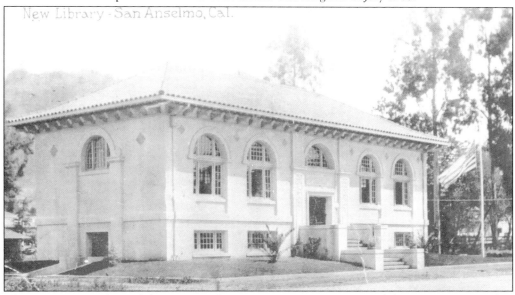

The energetic members of the San Anselmo's Women's Improvement Club were instrumental in obtaining a $10,000 grant from Andrew Carnegie for the construction of the Mission/Spanish Colonial Revival–style library. The architect was W. Garden Mitchell, who had also designed the town hall. It was completed in 1915, and Bessie L. Wise was appointed as the first librarian.

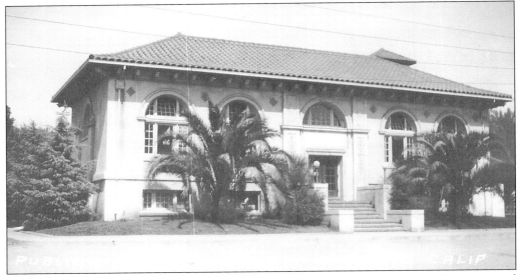

The San Anselmo Public Library was remodeled in 1960, with the original rectangle being squared with an addition to the rear. Craftsman detailing on the interior was maintained through the years and seismic upgrades were made in 1995–1996. The basement of the library, which held offices, the historical museum, and book storage, was severely damaged during the floods of 1982 and 2005.

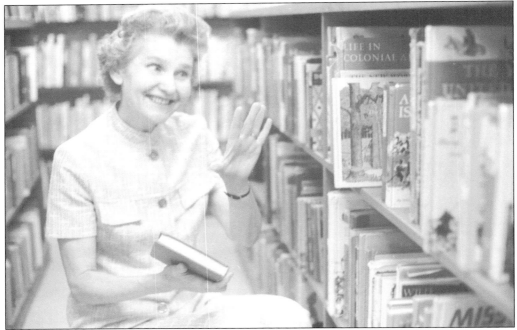

Jean Merian retired in 1978 after serving as the children's librarian at the San Anselmo Public Library for 25 years. She was everything a children's librarian should be: kind, soft-spoken, and meticulous. She had a profound affection for children's literature and a belief in the transformational effects of reading in general, but her greatest gift may have been her ability to select the right book for each child who came across the yellow linoleum floor of the Children's Room.

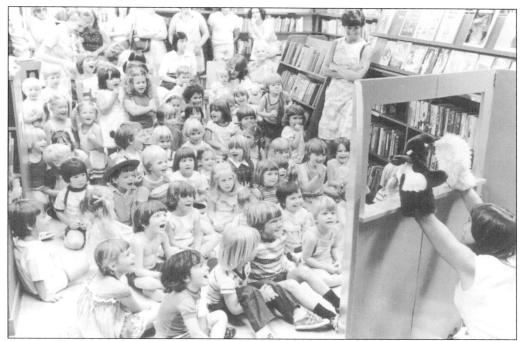

The San Anselmo Public Library has always had a strong focus on services, programs, and book acquisitions for children. In this 1978 image, youngsters enjoy a puppet show in the library stacks.

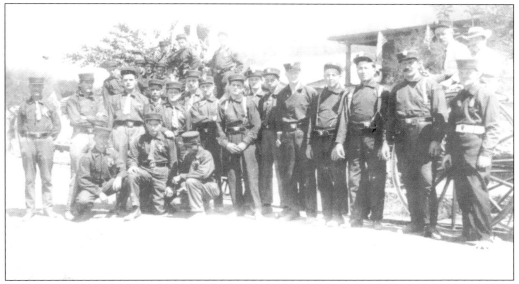

The San Anselmo Volunteer Fire Department was formed in 1907, shortly after incorporation. In the early days of fire protection, the men were summoned to pull the hose reels by beating a large iron wheel with a mallet. Then the town purchased a horse-drawn hose wagon with a chemical tank. When the alarm bell sounded, the first man to hitch his team of horses to the wagon earned $5.

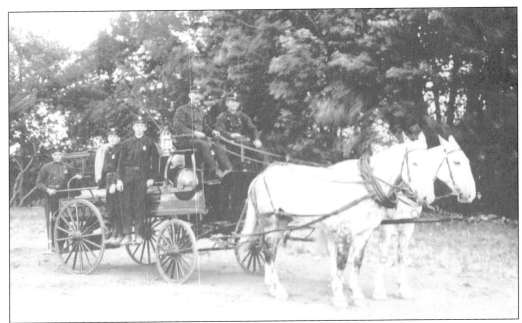

The brave men who battled fires in early San Anselmo had help from two trained fire horses named Major and Colonel, who were purchased in 1911 for $500. When the fire bell sounded, both horses stopped what they were doing and rushed into position in front of the wagon, anxious to begin the race to the fire. The firemen in this 1912 photograph are, from left to right, Dominic Ferrero, Tom Butler, Joe Flynn, fire chief Charles Cartright, and assistant chief Ernie Durham.

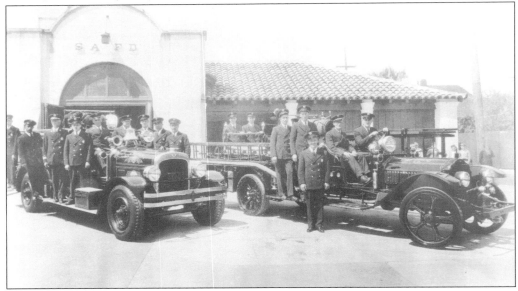

The fire engine on the right, the fire department's first motorized engine, was purchased in 1916 and built by Deysher & Lafargue, the town's own truck manufacturing plant. On the left is the Seagrave engine, which was purchased in 1930. Fire chief Charles Cartright stands in the center of this 1931 photograph. He was appointed chief in 1911 and was paid $70 per month for a seven-day workweek.

2

✗ Plane Crash · Bald Hill

NN-2-41— Time - 5³⁴ PM —

Received call at this time that an airplane had crashed on Bald Hill. After receiving a flood of phone calls we could not get a definite location. So called chief to investigate. Finally received a call from Chamberlain at end of Oak Ave that the crash was just above their home. Chief investigated and reported that there was nothing we could do. Reported same to Hamilton Field Authorities and called Coroner. Investigation disclosed that there were two Army P-40 type planes crashed. Pilots were believed instantly killed were Lieut. RE Steckman a Thomas LeRoy Traux.

(signature)

Handwritten logs were maintained by the San Anselmo Fire Department in the early days. This log entry from November 2, 1941, describes a tragic event. Two low-flying Army P-40 airplanes crashed into the side of Bald Hill in heavy fog, killing the two pilots, Lt. Russell E. Steckman and Lt. Thomas Leroy Truax. A third pilot, Walter V. Radovich, bailed out of his plane near Lucas Valley Road. The San Anselmo police and fire departments were on the scene, followed by Hamilton Field personnel and a steady stream of curious spectators and souvenir hunters.

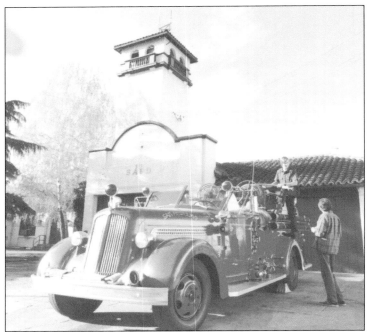

A new fire station was built at 777 San Anselmo Avenue in 1977, and the old station, seen here, was demolished during the major remodel of the town hall complex. This 1949 Seagrave truck was still in regular service in the mid-1970s. Originally, the cotton fire hoses were hung from the outside of the tower to air-dry after each use.

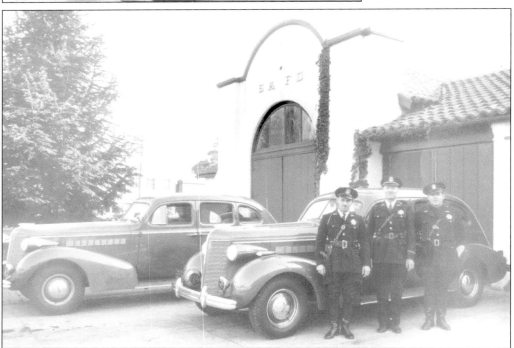

The San Anselmo Police Department was a small operation in 1938, including, from left to right, officer Dewey Vickery, Chief Donald T. Wood, and officer Mansfield Lewis. Wood served as police chief from 1930 to 1959. He also served as street superintendent, purchasing agent, deputy health officer, and tax collector. The Buick Series 40 patrol cars were purchased in 1937 and were the first police vehicles in Marin County equipped with two-way radios.

In 1955, the San Anselmo Police Department included, from left to right, (first row) assistant chief Sam Serio, Chief Donald T. Wood, and Sgt. Ray Velati; (second row) Chet Orr, James Orr, Gordon McNear, and Jack Chambers; (third row) Jim Farmer, Cliff Parlee, Harold Matteucci, Sgt. Raymond Buchignani, and Attilio DeMaestri.

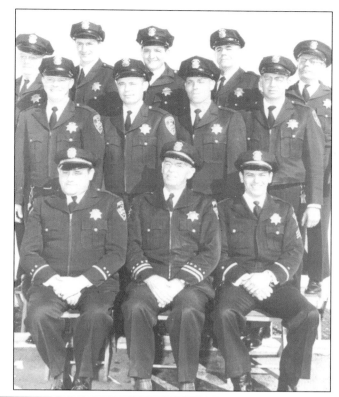

In the c. 1960 image below, Sgt. George Alberigi sits astride the police department's three-wheeled motorcycle. The town council approved the purchase of the Harley-Davidson motorcycle for parking control in 1946. The expenditure represented $899 out of the department's annual equipment replacement budget of $1,500. Prior to the purchase of the motorcycle, a policeman did the rounds to mark tires on foot.

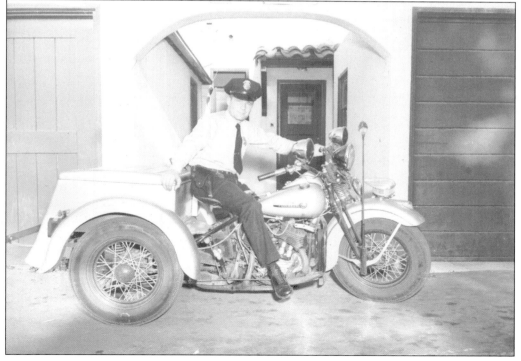

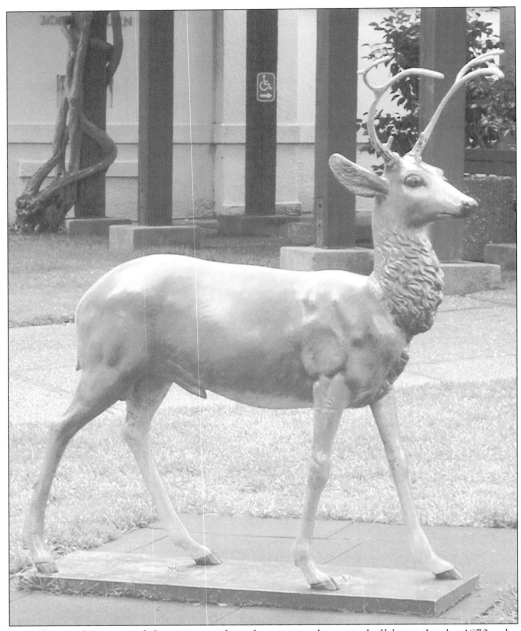

Sugarfoot is the name of the cast-iron deer that graces the town hall lawn. In the 1870s, the deer stood in the North Beach garden of Commodore Theodore H. Allen. The Dondero family purchased Allen's property, and when the 1906 earthquake and fire destroyed their home and garden, the statue was saved. The Donderos moved to San Anselmo in 1914 and brought Sugarfoot with them to their new home at 1659 San Anselmo Avenue, where he was admired by the neighborhood children. The Donderos donated him to the town in 1963. Since then, generations of San Anselmo's children have climbed on Sugarfoot and grabbed his antlers for a pretend ride in the woods. Sugarfoot is a survivor, having stood shoulder-deep in water and been left coated in mud by the floods of 1982 and 2005.

Six

SLEEPY HOLLOW

The beautiful valley of Sleepy Hollow was originally part of Domingo Sais's Cañada de Herrera land grant. When Sais died, his eldest son, Pedro, inherited the valley's 1,900 acres and leased them to Harvey Butterfield for a dairy ranch. Butterfield moved on in 1876, and the ranch was sold to Peter K. Austin and Ebenezer Wormouth, who sold his share to Warren Dutton. Austin planted eucalyptus and poplar trees along the dirt road. San Francisco whiskey dealer Anson P. Hotaling purchased the valley property in 1887, and his son Richard built a mansion at the end of the road in 1900. Richard Hotaling imported a herd of Holsteins, modernized the dairy ranch, and named it Sleepy Hollow Ranch.

Hotaling returned to San Francisco and leased the dairy to Sigmund Herzog of San Rafael. Herzog operated a "certified dairy" in the valley until he relocated to Sonoma County in 1925. The Hotaling heirs sold the ranch to a syndicate whose plan to build a large resort hotel in Sleepy Hollow was dashed in 1929 with the crash of the stock market and the beginning of the Great Depression.

Sleepy Hollow Golf Course opened in 1937 and was said to be the second longest course in the nation. Unfortunately, it closed after only four years due to lack of cash, legal problems, development pressures, and the diversion of water to Hamilton Air Force Base. World War II had begun, and the old dairy barns were commandeered by the US Army for use as an ammunition supply point from 1942 to early 1944. The soldiers on the well-guarded eight-acre site renovated the barns and stables and built housing.

The closure of the golf course did not deter interest in developing Sleepy Hollow. Lang Realty brought the dreams of expansion to life though its emphasis on single-family living. Lang began the subdivision of Sleepy Hollow in the early 1930s and opened a tract office at the corner of Deer Hollow and Butterfield Roads in the 1940s, selling one-acre residential lots. Paving contractor Albert G. Raisch purchased the upper 512 acres in the valley in 1943.

Like other neighborhoods in San Anselmo, Sleepy Hollow grew in the post–World War II years. By 1954, the community had a clubhouse and a pool and 200 homes had been built. The Dominican Sisters purchased the Raisch property and opened San Domenico School in 1965.

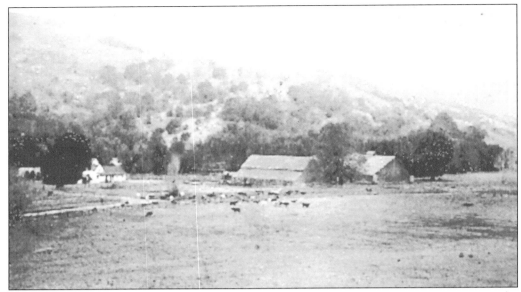

This is the earliest known photograph of the dairy in Sleepy Hollow, dating from 1893. The Dalessi family was operating the dairy at the time, having leased it in the early 1880s. The milk was delivered by wagon to San Rafael and the vicinity.

Butterfield Road is seen here lined with poplars and eucalyptus in the 1930s. It was named after Harvey H. Butterfield, who first leased the valley from Pedro Sais for a dairy ranch in 1860. Butterfield fenced the land and built a ranch house for his family.

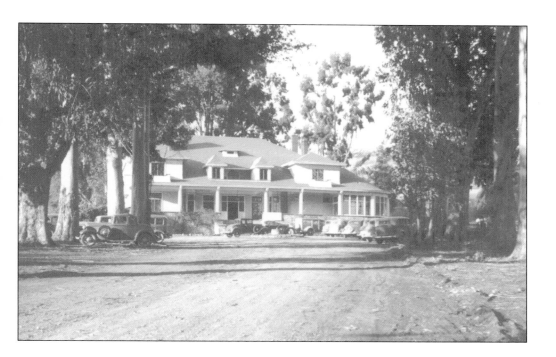

Richard M. Hotaling was the bachelor son of Anson P. Hotaling, the founder of a wholesale wine and liquor business in San Francisco. In 1900, the younger Hotaling built an elegant country home at the upper end of the valley. A wealthy bon vivant, he spared no expense on the home or on subsequent entertainment. The mansion is seen above and below in the 1930s after it was sold by the Hotaling family and transformed into the clubhouse for the Sleepy Hollow Golf Course.

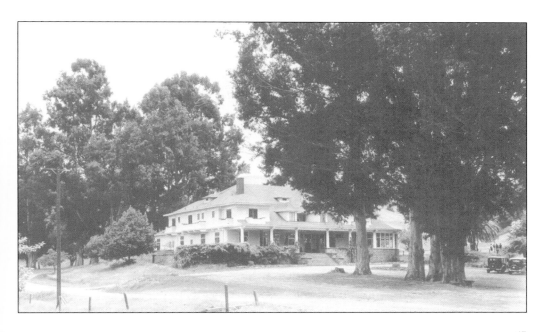

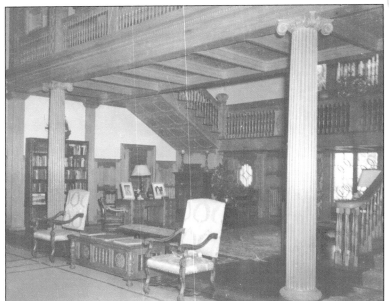

Architect Edward L. Holmes designed the Hotaling mansion for lavish entertaining and had numerous suites of rooms with private baths. The grand staircase inside was made of imported, hand-carved cedar. Hotaling, a well-known amateur Shakespearean actor, included a stage and balcony in the parlor for theatrical performances. A wardrobe room built in the hallway provided a stage door.

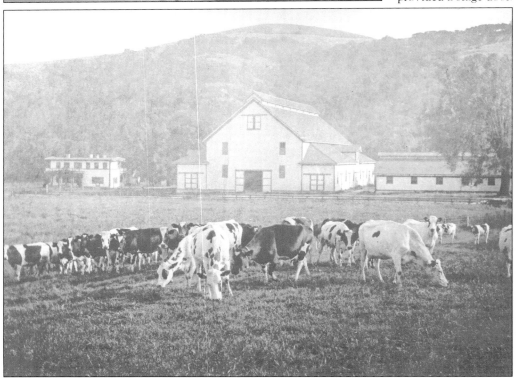

The dairy in the valley had been under lease, but Richard Hotaling decided to operate it himself. He enlarged and modernized the barns and silos, hired a dairy manager, and imported a herd of Holstein cattle from Holland. He named the ranch Sleepy Hollow, and his prize-winning bull was called Legend of Sleepy Hollow. Milk from the ranch was sold in San Francisco. After the 1906 earthquake, Hotaling gave all the butter and milk produced at the ranch to a relief camp.

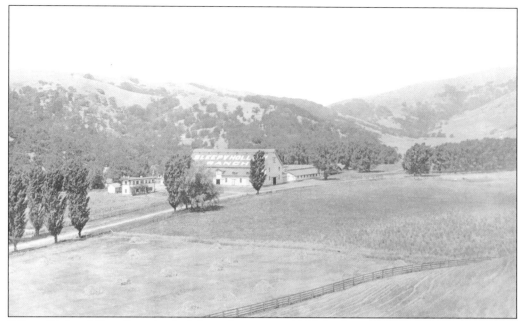

When Richard Hotaling tired of dairy farming in 1906, he leased Sleepy Hollow Ranch to Sigmund Herzog, a San Rafael butcher who had previously purchased cows from the dairy ranch. Herzog operated a model "certified dairy"—the dairy was inspected frequently, the herd was free of tuberculosis, cows were washed regularly, milkers wore sanitary garments, and the barns and bottling areas were kept immaculately clean.

Russell H. "Bobby" Robinson was two years old when his family moved to Sleepy Hollow in 1918. His father, Russell T. Robinson, was hired to manage Sigmund Herzog's certified dairy. At the time, there was a crew of 35 and a dairy herd numbering around 200. The 1920 census lists the Robinson family along with two cooks, seven milkers, two butter makers, and nine laborers as residents at the Sleepy Hollow Ranch.

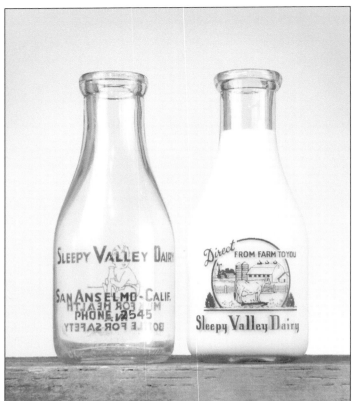

When the Hotaling heirs sold their property in the valley in 1925, Sigmund Herzog moved his dairy to Petaluma and took the name Sleepy Hollow Certified Milk Company with him. In the 1930s, Joseph A. Fagundes leased the ranch house and some of the acreage. He produced milk under the label Sleepy Valley Dairy until 1942, when the US Army took over the site as an ammunition supply depot. Fagundes sold bottled milk to customers at the dairy. (Photograph by Charles Kennard.)

This view of Mount Tamalpais was taken from the Fawn Drive area of Sleepy Hollow in the 1930s. The poplar and eucalyptus trees were planted along Butterfield Road in 1878 by Peter K. Austin. Sleepy Hollow Creek is in the center of the photograph.

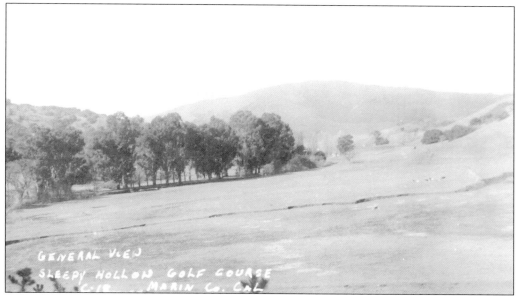

George Kaenal and H.A. "Polly" Willard, golf enthusiasts and promoters, saw the potential in the valley for a golf course and opened Sleepy Hollow Golf Course in 1937. The 18-hole course was advertised as the second longest in the United States and the only one with an extra par two 19th hole. The Hotaling mansion served as the clubhouse.

The Sleepy Hollow Golf Course was a "pay as you play" course that ran south along both sides of Butterfield Road. It was very popular and considered one of the best courses in the Bay Area. This advertisement for the course appeared in the *San Anselmo Herald* in 1938.

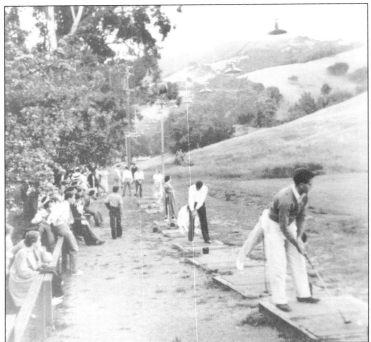

Sleepy Hollow Golf Course was complete with a flood-lit driving range and putting green and offered professional instruction. (Courtesy of the Fairfax Historical Society.)

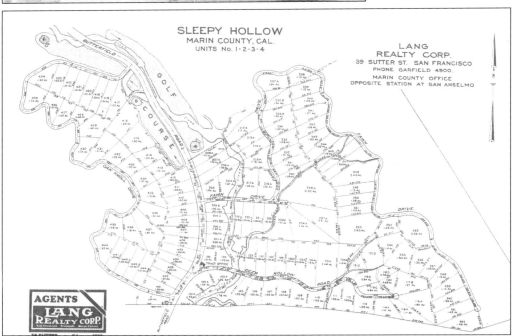

In 1925, the *San Anselmo Herald* notified the public about the "conclusion of a real estate deal whereby the Sleepy Hollow Ranch . . . is to become a highly exclusive residential tract." The development of Sleepy Hollow by the Lang Realty Company was delayed, however, until 1932. A tract office opened at the corner of Deer Hollow and Butterfield Roads in the 1940s, offering 141 one-acre residential lots for sale. (Courtesy of the Fairfax Historical Society.)

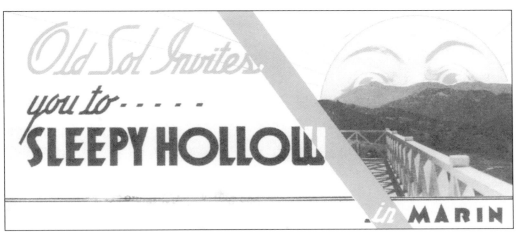

Old Sol Invites
you to
SLEEPY HOLLOW
...in MARIN

"You can play where you live in Sleepy Hollow" was a slogan used by Lang Realty. Advertisements promoted the 19-hole golf course that was just beyond folks' doorsteps, the saddle horses ready for an early-morning or moonlight ride, the wooded trails, and the balmy weather—all with the convenience of a modern home.

Harold G. Stoner, seen here, worked as the supervising architect for Lang Realty, and all house plans were subject to his approval. David Adams was the sales manager for the tract. On one of the 35 lots initially put up for sale in Sleepy Hollow along Deer Hollow Road, Stoner chose to build a Norman Provincial-style home at No. 18, where he lived with his wife, Jeanne, and his children, Hal and Joan, from 1936 to 1943. (Courtesy of the Stoner family.)

During the 1939 Golden Gate Exposition on Treasure Island, the San Francisco Board of Realtors organized a model-home tour of 30 architect-designed homes in the Bay Area. The sixth stop on the tour was at 701 Butterfield Road in Sleepy Hollow, seen here. Sales agent and builder David S. Adams (third from left) and developer Rudy Lang (fourth from left) pose with a group of entertainers. (Courtesy of Audre Labelle.)

Albert G. Raisch, a paving contractor, and his wife, Katherine, purchased the upper 512 acres of the valley in 1943. Raisch and his family moved into the Hotaling mansion and made some changes to it, adding fresh paint, modern plumbing, and the addition of a swimming pool, an artificial lake, and a dancing pavilion. The Raisches continued the tradition of throwing lavish parties in the house—they were known to entertain as many as 600 guests.

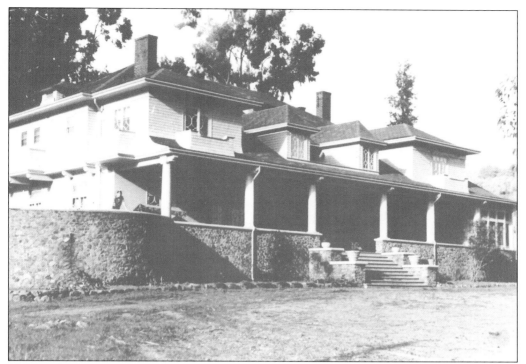

In 1955, the Raisch family moved to San Francisco, and on February 17, 1957, the vacant 18-room mansion burned to the ground in an early-morning fire. Arson was suspected. Today, only the steps and the ruins of the elegant home's foundation remain.

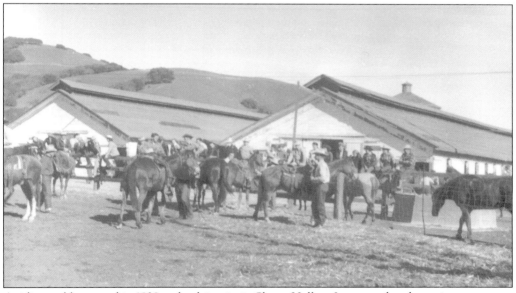

A riding stable opened in 1938 at the dairy site in Sleepy Hollow. It operated under various managers and names, including Fresh Air Riding Academy, Sleepy Hollow Riding Club, and Sleepy Hollow Stables. It closed during the US army's occupation and then reopened. The stables closed in the early 1970s when Joseph Eichler subdivided the land and built 15 new homes.

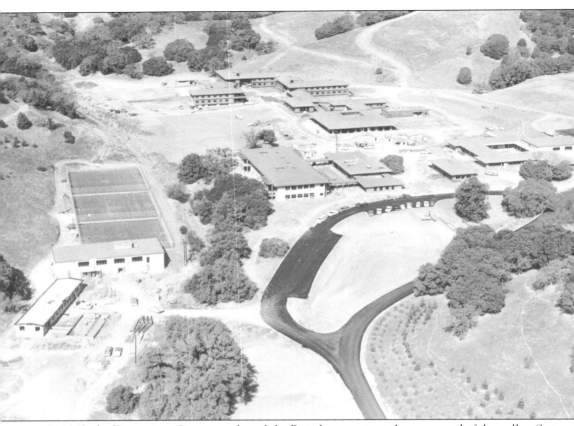

In 1963, the Dominican Sisters purchased the Raisch property at the upper end of the valley. San Domenico School is seen here under construction in 1965. The school was officially dedicated on April 30, 1966. (Courtesy of the Fairfax Historical Society.)

Seven

DOWNTOWN AND NEIGHBORHOOD BUSINESSES

There were only a few businesses in San Anselmo before 1900, including a couple of hotels, a small grocery, a campground and nursery, and a blacksmith. As refugees from the 1906 earthquake and fire in San Francisco made San Anselmo their permanent home, merchants set up shop to meet the growing demand.

At first, it was not clear where the primary business district would develop. The Hub, the junction of the railroad and the two main county roads serving travelers on foot, horseback, buggy, and stagecoach, was an ideal location for early businesses related to transportation. William Deysher and Ben Lafargue owned a blacksmith shop there that evolved into a booming enterprise building railroad cars and trucks. By 1908, numerous businesses were clustered opposite the station on the east side of the county road (now Sir Francis Drake Boulevard). Other stores and businesses serving residents near the San Francisco Theological Seminary were on southern San Anselmo Avenue and lower Ross Avenue.

In 1910, when James Tunstead donated land from his Linda Vista tract for a town hall and firehouse, the main business district began to develop closer to the new center of the town along San Anselmo Avenue. By 1915, San Anselmo boasted businesses to satisfy most any need. Confectioneries, bakeries, ice cream parlors, dry goods stores, drugstores, a butcher, groceries, vegetable markets, coal and lumber purveyors, barbers, and laundries were thriving in the new town.

There were numerous real estate offices to handle sales at new subdivisions. One type of business that San Anselmo did not have until the end of Prohibition was a saloon, though there was a "blind pig" or two, where townspeople could illegally purchase an alcoholic drink.

In the early 1900s, there were small, family-owned grocery stores scattered throughout San Anselmo's neighborhoods, often near one of the railroad stations. Dairy ranching remained a primary business in rural areas like Short Ranch and Sleepy Hollow until after World War II.

In the 1960s, a new business area developed at Red Hill with an anchor grocery and a pharmacy. However, the downtown has remained much as it was, with small shops and restaurants.

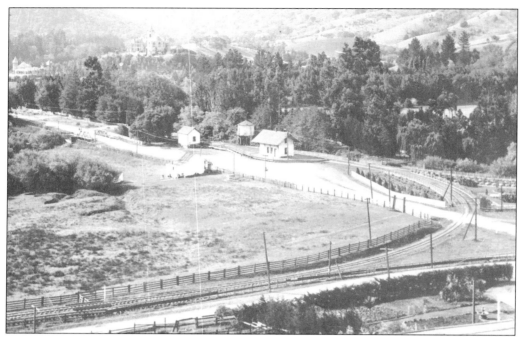

A small grocery and candy store opened across the road from the railroad depot in 1895. It was operated at various times by H.J. de Fiennes, Herman Zopf, and Mary Needham. Visitors, many of whom came by train to camp and picnic under trees near San Anselmo Creek, purchased groceries and novelties here and got water from a faucet behind the store. Needham's daughter Bessie was known to surreptitiously and illegally serve liquor from a teapot.

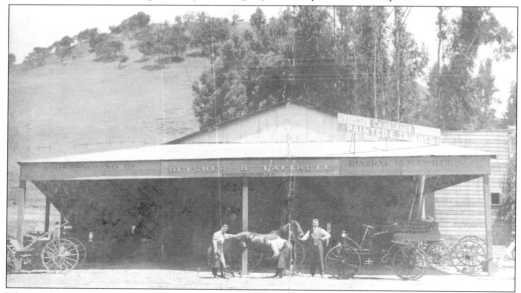

The road from San Rafael to Fairfax passes at the foot of Red Hill, an ideal location for a blacksmith. In the late 1880s, Theodore Mundt opened a blacksmith shop here, and later William Deysher and Ben Lafargue adapted their operation and became builders of railroad cars, trucks, and fire engines. Deysher & Lafargue is seen here in 1908.

Shapira's Pharmacy was owned by Rose Shapira in a time when women did not commonly enter business or professions. Shapira, standing at right, graduated from pharmacy school in 1905 as the only woman in her class. By 1908, she had opened a pharmacy at the base of Red Hill. She provided professional advice and friendly counsel night and day. (Courtesy of the Marin History Museum, Roy Farrington Jones Collection.)

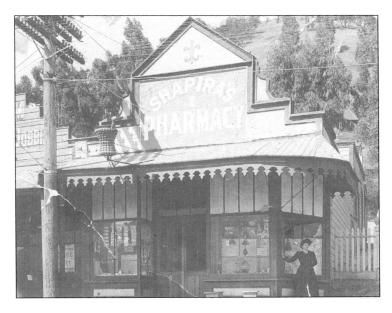

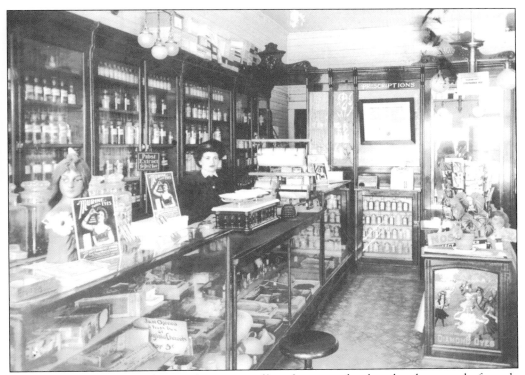

In 1917, Rose Shapira, seen here in the interior of her pharmacy, developed and patented a formula for tooth powder that she manufactured in partnership with her brother-in-law Mark Sherwin. Advertisements claimed that Sher-Pira Tooth Powder cleaned and whitened teeth, prevented the accumulation of tartar, prevented and treated pyorrhea, and contained nothing that would injure teeth and gums. (Courtesy of the Marin History Museum.)

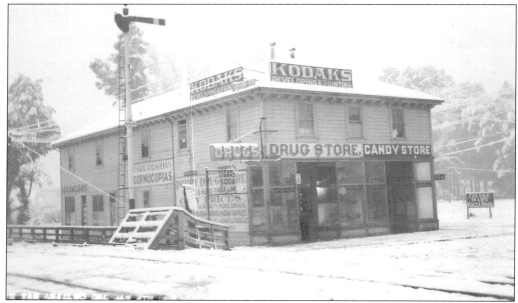

In 1909, George Hund opened a drugstore at the corner of Tunstead and San Anselmo Avenues. It was called Poppy drugstore, or simply Hund's. The store sold everything from baseball gloves to ice cream sodas as well as pharmaceutical supplies. The store was the first business in town to have an illuminated sign. It is seen here during a rare snowstorm in January 1913.

When the Mercantile Trust Company purchased the property at Tunstead and San Anselmo Avenues for their new bank in 1925, the building that had housed Hund's drugstore was moved to 339 San Anselmo Avenue. It has served as a boardinghouse or hotel since then. In 1926, Hotel Anselmo offered sunny rooms with hot and cold running water for $1 to $1.50 per day or $4 to $5 per week. (Courtesy of the Marin History Museum, Roy Farrington Jones Collection.)

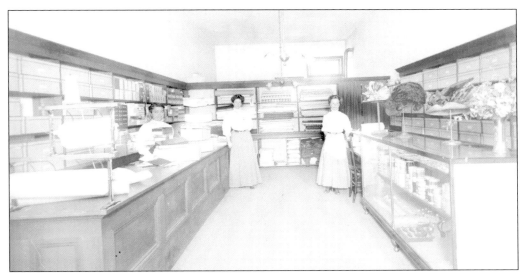

This is the interior of one of the first dry goods stores in town. A wide variety of goods were carried, including yardage, ribbon and sewing supplies, ready-made clothing, and hats. G.S. McWilliams and F.J. Hart were dry goods merchants in San Anselmo in 1910.

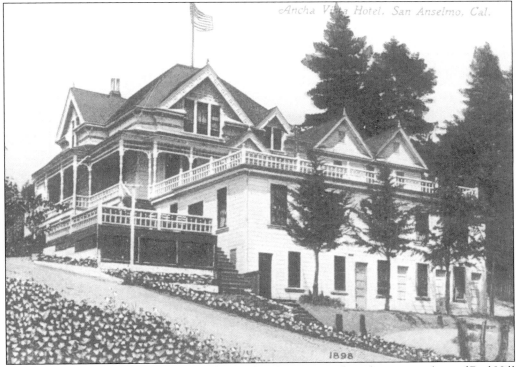

The largest hotel in San Anselmo was the Ancha Vista, situated on the eastern slope of Red Hill with a magnificent view of Bald Hill and Mount Tamalpais. It was originally a private home but was converted into a hotel in the late 1890s. It had rooms and cottages for 150 guests, expansive grounds, and springs with "curative" properties. Rates were $2 to $3 per day. The hotel was in operation until the early 1930s.

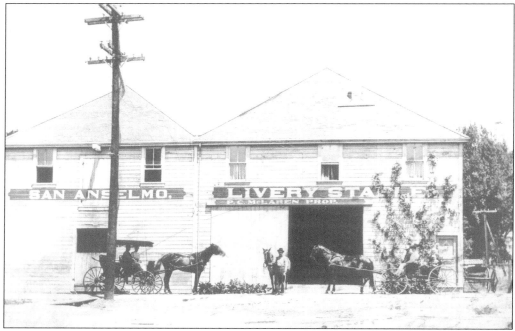

The Peter McLaren family had a thriving business tending to the care and repair of horses and carriages on Ross Avenue. Travelers to town on the train often found it convenient to rent a horse and buggy to continue on to their destination. In later years, when the automobile replaced the horse as a means of transportation, the San Anselmo Livery Stable was converted to an automobile repair shop. The family's living quarters were upstairs in this 1905 photograph.

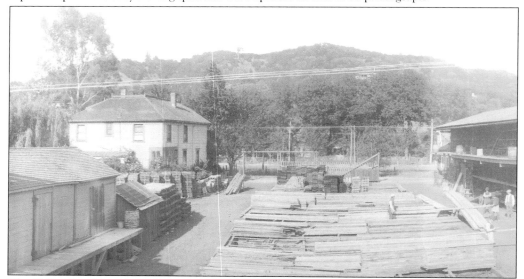

The E.K. Wood Lumber Yard opened in 1905 on San Anselmo Avenue between Belle and Mariposa Avenues. It was the largest and most complete lumberyard in the area, with a woodshop that turned out moldings of every description. A railroad spur track ran into the yard. This view looks east toward the railroad tracks and San Anselmo Avenue. In July 1918, a spectacular fire destroyed a large amount of lumber and parts of the yard.

Numerous businesses were already established along the east side of the county road near the Hub when the property owners raised the rents in 1910. The original buildings, seen here, were moved or demolished as a result, and other eager merchants and developers quickly constructed new commercial buildings, which still stand today.

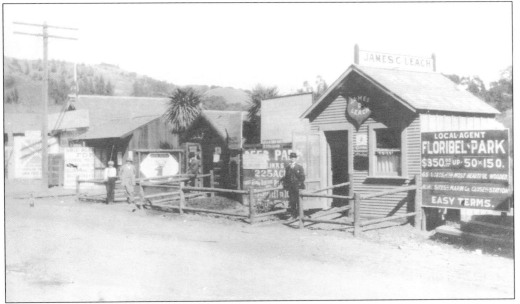

The 200 block of Sir Francis Drake Boulevard was commonly known as "Real Estate Row" to some and laughingly referred to as "Robbers' Row" by others. The original offices in the block were replaced around 1911, and many of the new ones still served as real estate offices. Here, James C. Leach stands in front of his small office.

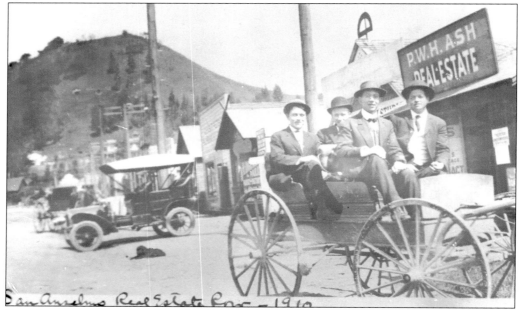

San Anselmo Real Estate Row – 1910

Eager for commuter revenue, the railroad sought to encourage the growth of the towns along its route. Waiting rooms and ferry cabins featured advertisements for "villa sites" subdivided from the formerly large landholdings. The railroad offered special round-trip fares to San Anselmo, where arriving trains were met by agents who would escort perspective buyers to the new subdivisions.

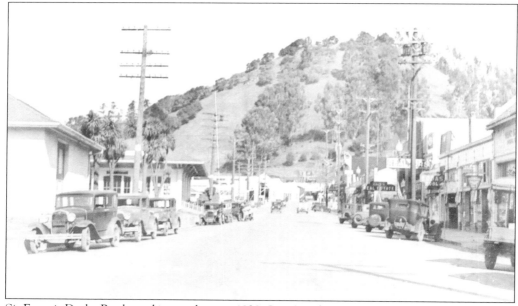

Sir Francis Drake Boulevard is seen here in 1938. San Anselmo Station is on the left, and almost all the storefronts in the first block on the right were occupied by real estate offices. (Courtesy of Jim Staley.)

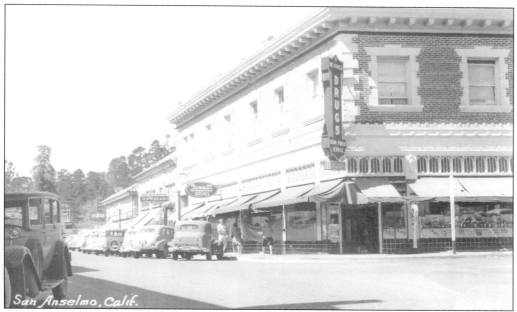

The Cheda Building, on the corner of Tunstead and San Anselmo Avenues, was designed by Thomas O'Connor of San Rafael and built in 1911 for the Cheda brothers of San Rafael's Marin County Bank. It replaced the Hotel Rossi, which had catered to weekend and summer visitors and was destroyed by fire in December 1910. The two-story redbrick building with grey trim had 22 rooms upstairs and five storefronts downstairs. Drugstores were tenants of the Cheda Building for many years. In 1925, Nick Phelan opened a pharmacy, which Eddie DeLong purchased two years later. DeLong's (above) flourished for many years until it was purchased by William John "Jack" Minnes in 1948. Minnes renamed the store Jack's Drugs (below). Jack's moved to Tunstead Avenue in 1962. Barber Mel Bridges has been in the Cheda Building since 1945. (Above, courtesy of the Marin History Museum, Roy Farrington Jones Collection.)

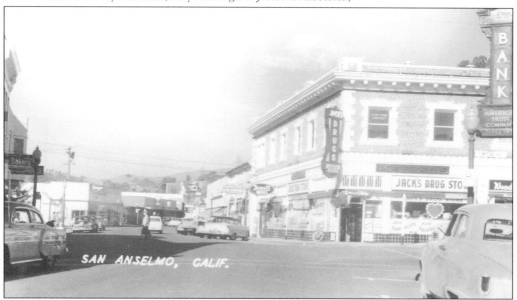

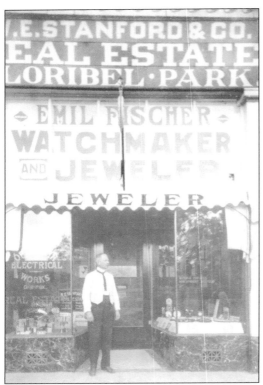

Watchmaker and jeweler Emil Fischer, a native of Germany, opened a shop in the newly completed Bauer Building on the east side of Sir Francis Drake Boulevard in 1912. A year later, Fischer constructed a building on San Anselmo Avenue where he and his wife, Olga, operated the Tivoli Hotel and Restaurant.

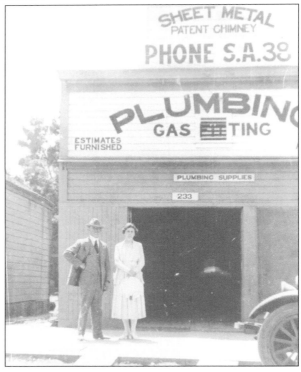

Arthur and Mary Daggett stand in front of Daggett Plumbing Company in 1925. Arthur Daggett and William Tobin started the business in 1922 in what was originally a neighborhood grocery store. Tobin was tragically killed by a train at the Pastori railroad crossing in 1923. Daggett ran the business until his death in 1964, when Mary Daggett's nephew Frank Kiernan took over the business. Today, her grandnephew Michael Kiernan is the owner, and plumbing parts are still stored in the original grocery bins labeled "Rice," "Lima Beans," and "Sugar."

AUTOMOBILE MACHINE SHOP

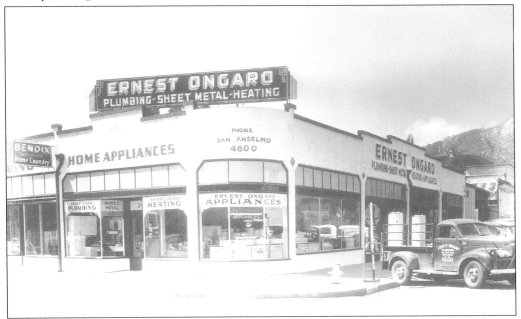

The Wessell Garage was originally built at the corner of Ross and San Anselmo Avenues around 1912 by William Wessell. Though not a mechanic himself, Wessell opened the automotive shop, hired a mechanic, and busied himself with the automobile parts department. His son Anselm worked alongside him, learning the trade. The building was purchased by Ernest Ongaro in 1939 for his plumbing business.

Ernest Ongaro opened a plumbing business in Fairfax in 1932. He expanded by purchasing the Wessell building in 1939 and moved the business to San Anselmo. He had a large showroom with appliances and fixtures. Ongaro's three sons, Donald, Ernest, and Richard, joined him in the business, and today, four of his grandsons, Ernest, Paul, Mitch, and Dean, own and manage the business.

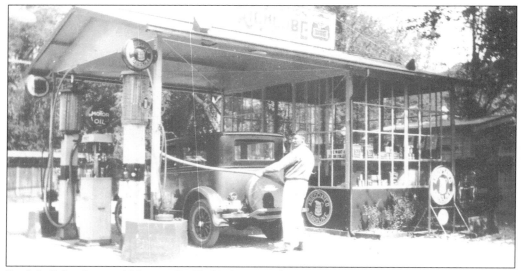

Emil A. Scherding and Maynor C. Clark's San Anselmo Service Station opened on the southeast corner of Sir Francisco Drake Boulevard and Barber Avenue in 1925. It had the first visible 10-gallon pump in Marin County. Special lighting directed toward the rooftop sign made it one of the most brilliantly illuminated stations on the road. (Courtesy of the Anne. T. Kent California Room, Marin County Free Library.)

GEORGE TONG

HAS OPENED A

Fruit and Vegetable Store

ON SAN ANSELMO AVENUE UNDER THE NAME OF

PANAMA COMPANY

and will be pleased to receive phone messages from his friends

PHONE S. A. 711

The Panama Market occupied several different locations on San Anselmo Avenue for more than 40 years. George Tong originally peddled fruits and vegetables in Ross Valley before opening a store in 1920. When Tong died unexpectedly at age 41 in 1930, his wife returned to China with their young children and sold the store to the Fong brothers of Fairfax. After that, Bing Fong ran the Panama Market, first at the corner of San Anselmo Avenue and Pine Street and then at 29 San Anselmo Avenue.

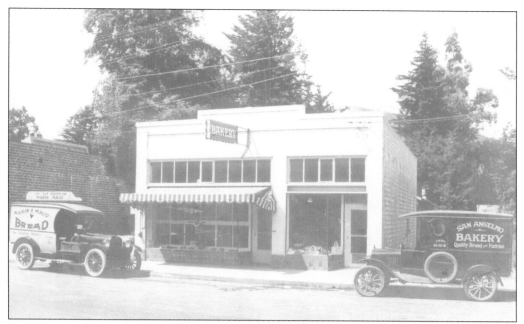

In 1922, Louis Kientz bought an existing bakery from Richard Guetter. In 1925, Kientz moved it across the street into this building. He introduced pre-sliced bread to Marin County in 1931 and was the first retail baker to offer home delivery. The northern storefront (right) was a candy and soda shop. After Prohibition, it became the first legal bar in San Anselmo, Louie's Inn.

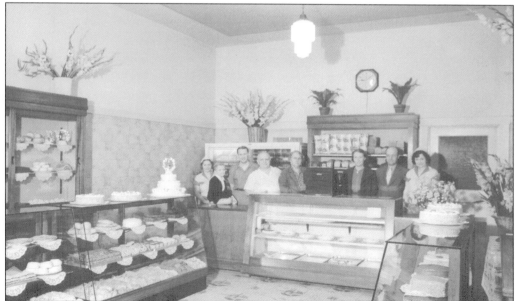

Three generations of the Kientz family posed for this photograph behind the counter in their San Anselmo bakery in 1936. They are, from left to right, Alice Capurro Kientz, young Richard Kientz, August Kientz, Louis Kientz, Laurence Kientz, Helen Morris Kientz, and two unidentified. Louis Kientz first ran the store, followed by his son August and his grandson Richard, who ran it for 57 years between them. The Kientz name is still on the building, below the awning.

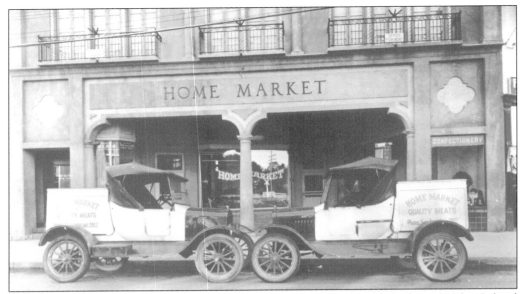

Home Market, once San Anselmo's most modern market, was established in 1926 by Gabriel Franchini and Leon Galatoire. It was a large store for its time, offering produce, groceries, a meat market, and a delicatessen all under one roof. The store also provided free home delivery. Upstairs in the building were medical offices. The Franchini family owned the building and meat market until 1974.

Roy and William, Gabriel Franchini's sons, joined their father in business at the Home Market. The store was noted for its window displays. This 1939 Christmas display was sculpted entirely of lard by Roy Franchini.

90

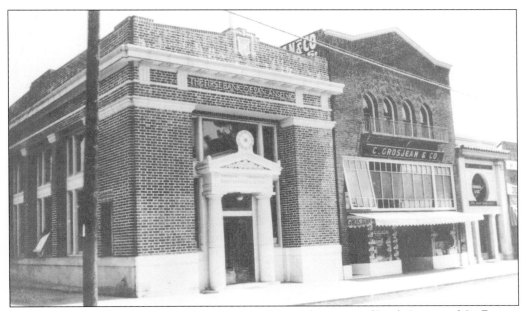

The First Bank of San Anselmo (left) opened in 1911 on the corner of Bank Street and Sir Francis Drake Boulevard. It was founded by Joseph C. Raas. The bank merged with the Mercantile Trust Company and eventually evolved into Wells Fargo Bank. Frank Howard Allen opened his real estate business in the building in 1923. In 1912, Camille Grosjean, a pioneer San Rafael grocer, opened a San Anselmo branch of C. Grosjean & Company in the adjacent building.

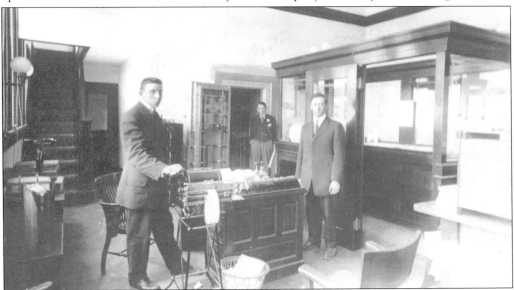

The Bank of San Anselmo was robbed in 1914. The bandit entered the bank and approached the window of cashier Thomas Butler (right), the only employee in the bank at the time. Butler tried to stall the bandit by handing over rolls of pennies, but the bandit caught on quickly, threatened Butler's life, and demanded more. Once the bold bandit had stuffed his pockets, he mounted his horse and dashed off. He was pursued by a posse but was never apprehended, getting away with $431. (Courtesy of the Marin History Museum.)

The Spanish Colonial Revival–style building on the right was constructed in 1924 for the Durham Garage and included a Dodge sales floor and showroom. It was designed by San Francisco architect and Ross resident Samuel Heiman, who described the building as "tending more to the artistic than the heretofore plain standard garage." Marin Oil Burner Company, H.C. Little Heating & Sheet Metal, and Clark's Furniture later operated in the distinctive building.

In 1969, Clark's Furniture was the tenant in the old Durham Garage building. Here, police captain Chet Orr bravely directs traffic at the Hub. Traffic signals were eventually installed at the busy intersection in 1972.

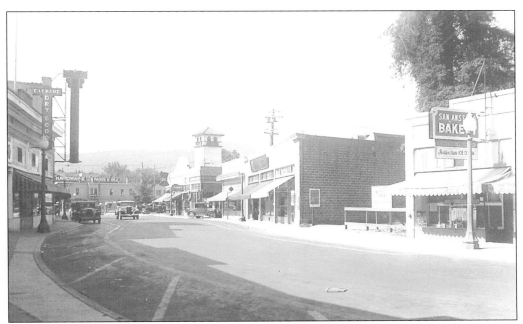

San Anselmo Avenue is captured here at a quiet moment with no traffic in the 1930s. On the right side of the street are the San Anselmo Bakery, a vacant lot, several storefronts, the San Anselmo Meat Market and Marin Creamery on the Magnolia Avenue corners, Rossi's Pharmacy, and the town hall tower. On the left side of the street are E.I. Crane Dry Goods and the Tivoli Restaurant.

This structure on Tunstead Avenue was known as the Arata Building. It was first leased to a steam laundry, and in 1920, the Valley Cash Market opened here. The Photo Shop became a tenant in 1947, sharing the building with Bob's Sports Center. The Photo Shop's name was changed to Seawood Photo in the 1960s.

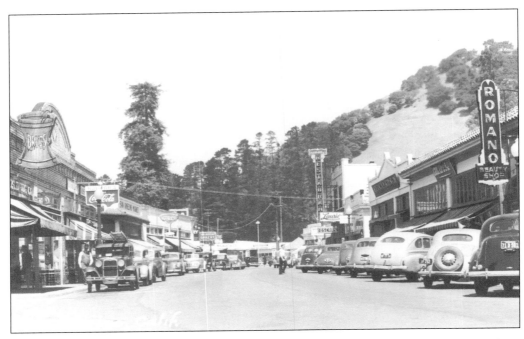

These two photographs show the north end of San Anselmo Avenue. They were taken about 13 years apart and show the dramatic transformation of the downtown after World War II. The photograph above, from 1943, shows the original architecture of the downtown buildings. In 1949, the Rossi brothers remodeled their pharmacy (left), enlarging it and adding a travertine facade. Buildings on the opposite side of the street were also given a modern makeover. The trees in the center background of the above image were removed from the north side of Sir Francis Drake Boulevard to make room for commercial development there.

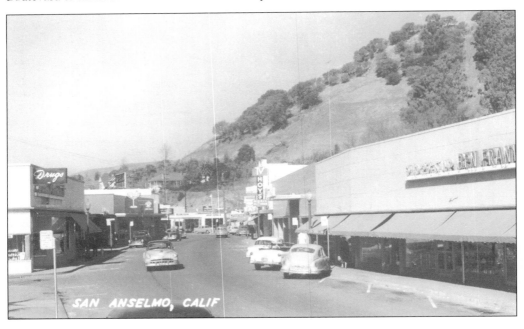

When Joseph and Frank Rossi built their new modern pharmacy on San Anselmo Avenue in 1949, they commissioned Spanish-born muralist Jose Moya del Pino to paint a mural, a casein fresco, on the interior rear wall. The mural depicts the history of pharmacy. A small section of the large mural is seen here.

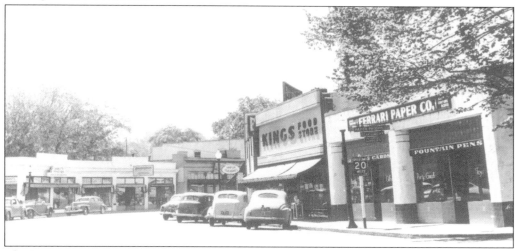

The Ferrari Paper Company moved to San Anselmo Avenue in 1938. Proprietor William Ferrari sold paper, typewriters, and office and school supplies. Gordon King moved to this location in 1936. On opening day, King's featured leg of lamb for 25¢ per pound, salmon for 18¢ per pound, cantaloupes at four for 10¢, and lettuce for 2¢ per head.

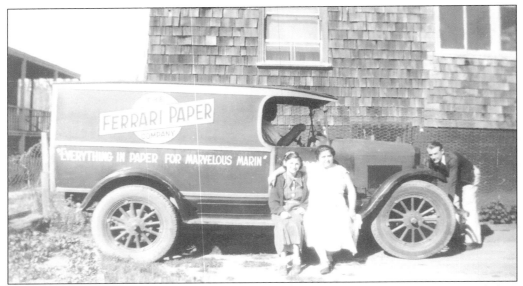

William Ferrari's store delivery truck is seen here with Ferrari's cousins and aunt. From left to right, they are Irene Zampatti, Mary Colombo, and Al Colombo, with Gino Zampatti in the driver's seat.

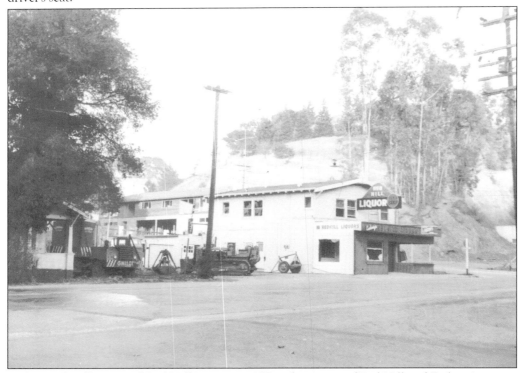

Ludwig Schwalbe opened Red Hill Liquor in 1937 at the corner of Red Hill and Forbes Avenues. Shortly after this 1958 photograph, the store was demolished to make room for United Market. Schwalbe opened a new store at the corner of Tunstead and San Anselmo Avenues. (Courtesy of the Marin History Museum, Roy Farrington Jones Collection.)

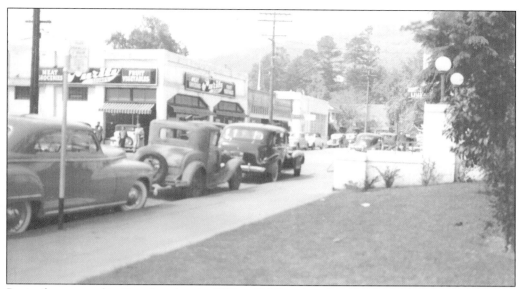

Purity first opened in San Anselmo in 1927 at 528 San Anselmo Avenue. The grocery relocated to Tunstead Avenue (above) across from the library in 1937, and three years later, it was renovated and redecorated, adding parking in the adjacent lot and a walk-in dairy refrigeration unit. Jack's Drugs moved to this site in 1962. Purity Stores opened a second grocery in San Anselmo, in addition to the one on Tunstead Avenue, at 102 Sir Francis Drake Boulevard in 1952 in a remodeled building formerly occupied by Safeway (below). Safeway moved to 121 San Anselmo Avenue, where the post office is today. (Both, courtesy of the Marin History Museum, Roy Farrington Jones Collection.)

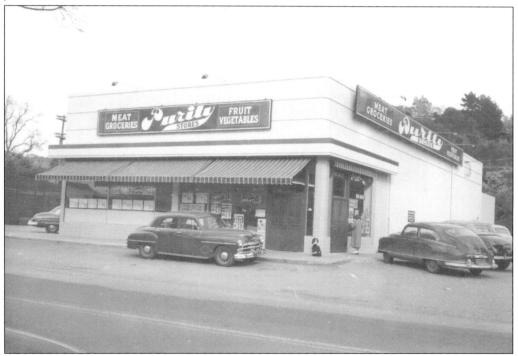

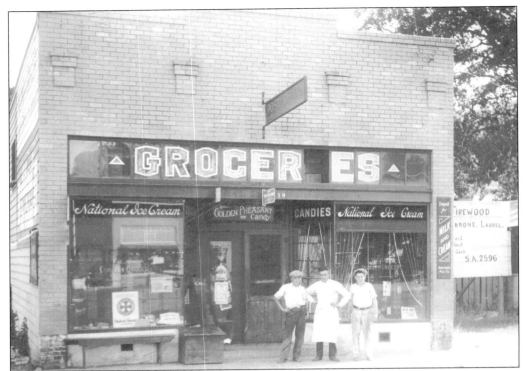

Neighborhood groceries were common in San Anselmo, especially near railroad stations. The Lavaroni family had a farm near the intersection of Elm and Scenic Avenues where they raised cows, chickens, and pigs. They opened this grocery store in 1915 at Yolanda Station. A branch of the post office was located in the store.

This unidentified woman stands in the 1300 block of San Anselmo Avenue. In 1912, Palm Market opened in the building on the left. The market's proprietors, Goodman and Hecht, sold meats, fruits, and vegetables.

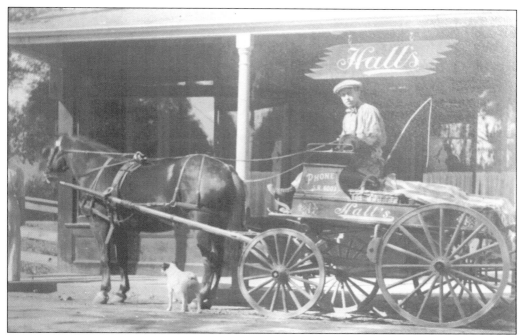

Irving J. Hall opened a small grocery at Lansdale in 1910. He delivered groceries in his horse-drawn cart and also sold ice cream. Hall lost his bid for a liquor license in 1913 when the local women protested, and he sold the store two years later.

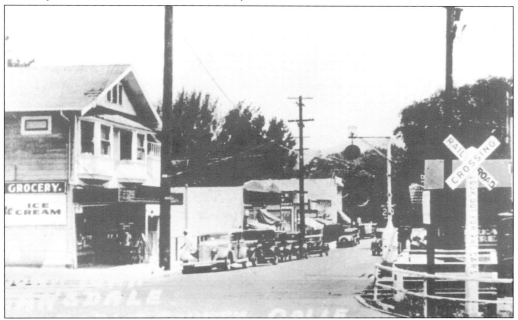

By the mid-1920s, Lansdale was a thriving little community with numerous neighborhood stores. Peter J. Cullen ran Lansdale Grocery (left), and Clarence Dykes had another grocery at the corner of Florence Avenue. A branch of the post office, Risdon Real Estate Company, a meat market, and a barber were also located at Lansdale Station. (Courtesy of the Marin History Museum.)

These two buildings on Ross Avenue have served San Anselmo in many ways over the years. Pioneer Hall (right) was built in 1905 and originally housed a grocery and butcher shop; upstairs was a meeting hall and a venue for dances and parties. The building on the left was a quarry office, a grocery, and the corporation yard for the town. In the 1950s, the U&I Trading Post opened. It carried an enormous assortment of odds and ends.

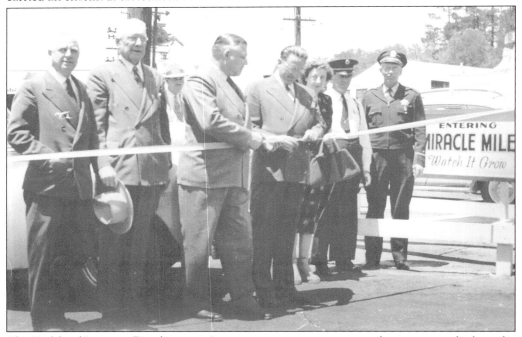

The Highland Intercity Development Association, anxious to promote business growth along the road between San Anselmo and San Rafael, encouraged the city councils to rename the roadway Miracle Mile. A new eastbound lane on the old railroad right-of-way was completed, making it a double-lane roadway. Attending the July 12, 1948, ribbon-cutting ceremony in San Anselmo were, from left to right, supervisors Fred Bagshaw, Robert Trumbull, and William Fusselman, Mayor Arthur Smith, councilwoman Carmel Booth, fire chief Nello Marcucci, and police chief Donald Wood. (Courtesy of the Marin History Museum.)

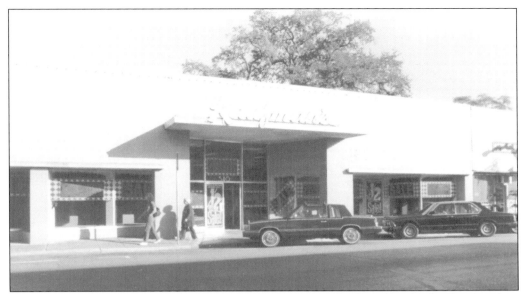

Kaufman's opened on San Anselmo Avenue in 1952. Mozart Kaufman bought the San Anselmo branch of Albert's, his father-in-law Harry Albert's department store, and changed the name. It was a landmark business in town that attracted shoppers from all over Marin. A men's clothing store opened in 1954 across the street. In 1969, Kaufman added fine French and English antiques to the inventory. The store closed in 1986.

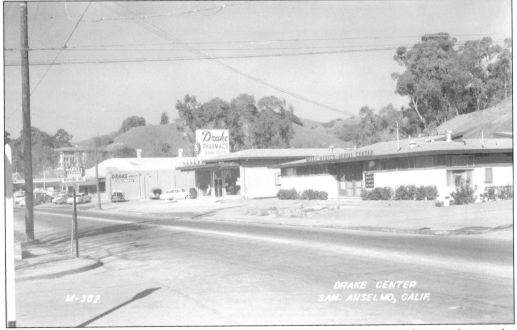

Sir Francis Drake Boulevard was still a two-lane road when this photograph was taken in the late 1950s—the road widening began in the early 1960s. The Sunny Hills Orphanage is on the hillside on the left. It was demolished in the mid-1960s. (Courtesy of the Anne T. Kent California Room, Marin County Free Library.)

Red Hill Shopping Center opened in 1967 on the former site of the San Francisco Presbyterian Orphanage and Farm (Sunny Hills). In this photograph, grading is under way for the Parkside Apartments on Sunny Hills Drive. (Courtesy of the Fairfax Historical Society.)

Felice Guasco started selling groceries and produce at the San Anselmo Market on the corner of San Anselmo and Magnolia Avenues in 1925. He relocated to 100 Center Boulevard in the 1950s and then expanded the market in the 1970s, as seen here. Guasco's closed and became Andronico's in 1995.

Eight

NEIGHBORHOODS, FAMILY, AND COMMUNITY LIFE

The beauty and climate of Ross Valley appealed to families seeking a vacation respite from San Francisco's summer fog. Camping alongside San Anselmo Creek was how many families first came to be acquainted with the San Anselmo area. The 1906 earthquake and fire in San Francisco prompted many of these families to make San Anselmo their permanent place of residence. The population of the town surged from 161 in 1900 to 1,531 in 1910.

The conservative influence of the San Francisco Theological Seminary and other early settlers ensured that San Anselmo had none of the rowdiness associated with saloons, as the neighboring towns of San Rafael and Fairfax did. Parents found it a safe and suitable place to raise their children.

Shortly after 1900, large tracts of land in San Anselmo were subdivided. The Barber Tract, the slopes of Bald Hill, the former property of Minthorne Tompkins on Pine Hill, the Short Ranch, and the Yolanda and Lansdale areas were soon dotted with residences. While a number of fine residences were built, some by notable architects of the day, most homes in San Anselmo were modest bungalows built by local carpenters and craftsmen.

As San Anselmo grew, so did the need for public schools. In 1893, Alexander Bouick, the groundskeeper for the seminary, provided space at his home for a makeshift school until San Anselmo School opened in 1898. With the influx of earthquake refugees, the school expanded and another was built in the Yolanda/Lansdale area.

Residents had a lot of things to do in the early days. The firemen sponsored dances at an open-air pavilion. America's favorite pastime found ardent fans in San Anselmo and local baseball teams like the Yolanda All Stars, the San Anselmo Wildcats, and the San Anselmo Merchants, among others, attracted large crowds. The first movie theater, a nickelodeon, opened in the Cheda Building in 1911, and the Tamalpais Theatre opened on Sir Francis Drake Boulevard in 1924.

After World War II and for the next two decades, San Anselmo, like the rest of the nation, found itself in the middle of an ongoing building boom. New neighborhoods were established and existing ones were developed further. From the late 1940s through the 1950s, community services and schools expanded as the town grew.

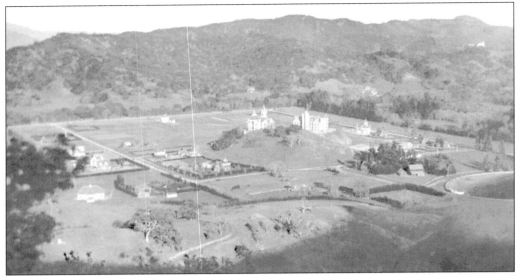

Sunnyside was San Anselmo's first subdivision. It was subdivided and the streets were named by George and Annie Worn in 1881. Lots were offered at auctions in 1881, 1887, and 1892, but sales were slow except for the lots purchased by Arthur Foster for the San Francisco Theological Seminary. In this 1903 photograph taken from Bald Hill, only a few scattered homes have been built along Ross Avenue.

Frederick Sproul Taylor, the youngest son of papermaker Samuel P. Taylor, purchased property in Sunnyside Tract at 102 Ross Avenue in 1892 and built this home in 1896. Today, it sits behind St. Nicholas Orthodox Church and serves as the parish hall.

Michael Butler, standing here with his family on their milk wagon in 1898 at San Anselmo depot, operated a dairy farm on leased land behind today's downtown fire station. A large milking barn was situated on Crescent Road. The milk was delivered via horse and wagon by Butler's daughter Margaret (holding the reins), who rose at 4:00 a.m. to begin her rounds.

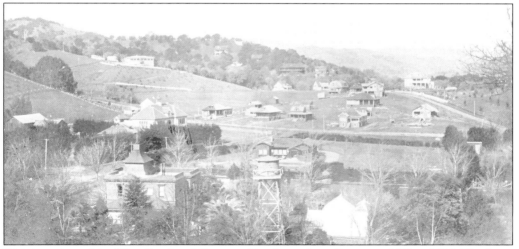

This is a view of the Woodland and Crescent Road area from Seminary Hill in 1908. The large house in the lower left was built in 1888 by James Wells Foss. It was sold to Dr. Charles Bauer in 1905 and demolished in the late 1940s for construction of the First Presbyterian Church. Beyond the Bauer home is San Anselmo School. On the right, Crescent Road runs up the hill to the E.K. Wood (Robson) home. On the hillside on the left is Idalia, the home of Joseph Raas, the founder of the Bank of San Anselmo.

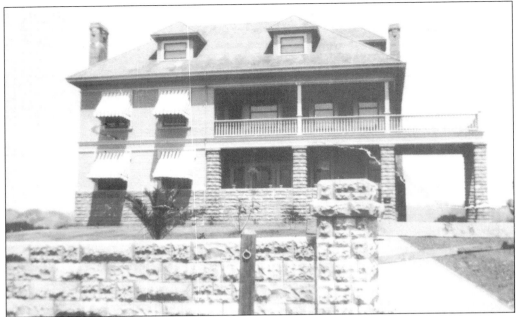

This dignified and imposing wood-frame mansion, at 237 Crescent Road, is the Robson-Harrington House. This San Anselmo landmark was completed in 1906 for Edwin Kleber Wood and his wife, Marian Thayer, on 2.68 acres. In April 1923, the Wood heirs sold the Crescent Road estate to Kernan and Geraldine Robson for $18,500. The Robsons planted extensive orchards and a vineyard and added the curving brick walls that surround the estate. Stonemasons adorned the grounds with archways, fountains, and elaborate wall niches with imported European scenes and plaques. The house and property were bequeathed to the Town of San Anselmo in 1967 with the condition that it be named Robson-Harrington Park as a tribute to the memory of Kernan Robson's father and mother. The house is shown above shortly after its construction and below in 1917.

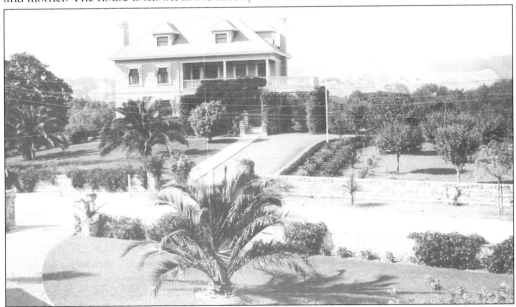

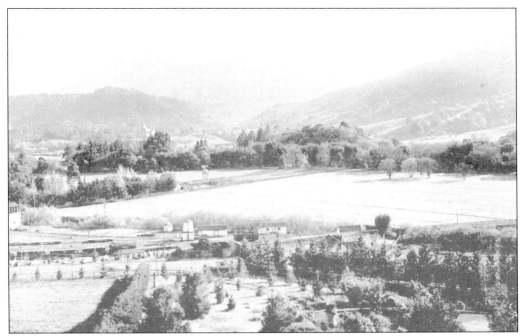

These two photographs were taken just 10 years apart. Above is an 1898 view from Red Hill overlooking part of the freight yard and the open hay field that was initially subdivided in 1901 as Ross Valley Park. By the time the lower panoramic photograph was taken around 1908, homes had been constructed along Tamalpais and San Rafael Avenues and in the Crescent Road neighborhood. Development of the downtown business area was still a few years off.

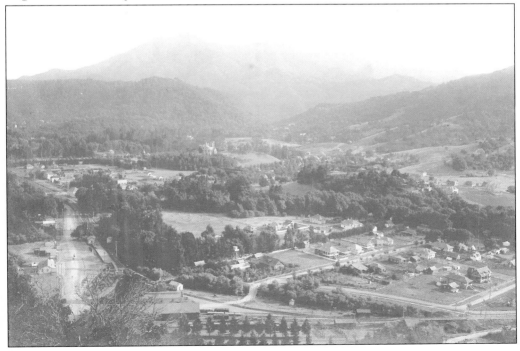

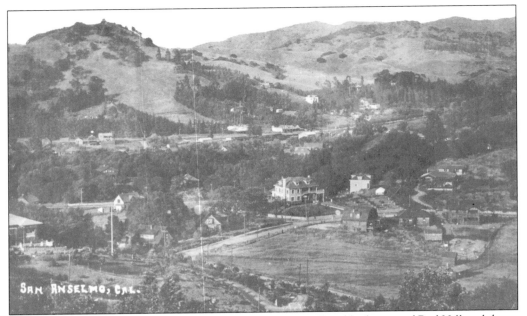

This interesting 1912 panorama taken from above Crescent Road looks toward Red Hill and shows the Robson-Harrington House with its carriage house to the right. The carriage house was destroyed by fire in January 1974. Beyond the house, running across the center of the photograph, is the San Rafael/Olema County Road (Sir Francis Drake Boulevard), with Red Hill rising above it.

Benjamin Sturdivant, a Spanish-American War veteran, purchased property in 1905 high on the hill in the Barber tract and built a large two-story house the following year. Sturdivant is seen here in 1907 holding his daughter Marion. On Joe, the family's horse, are, from left to right, Helene Sturdivant, Suzette Gagan, Tal Sturdivant, Jack Lipman, and an unidentified girl.

Grace and Fred Newell (right) engaged architect Julia Morgan to design a home for them in the Barber tract on Prospect Avenue. The barn, which still stands at the front of the property, was built first, and the Newells lived there until the house was completed in 1908. The Newell's nephew and niece, Chester and Dorothy Patterson, sit here in the newly constructed fireplace.

Many families camped in San Anselmo before they built permanent homes. At this 1905 campsite are, from left to right, San Francisco residents Annie Clayton, August Pasquet, and Catherine Pasquet. Even the family dog and canary—in the cage hanging above the table—were included. The Pasquets and Annie and Ernest Clayton made San Anselmo their home after the 1906 earthquake. (Courtesy of the Ernest Clayton Collection.)

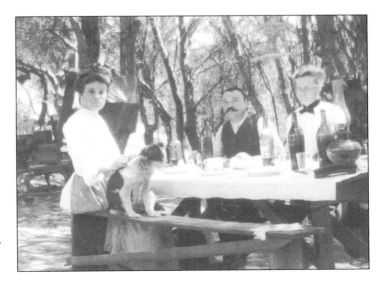

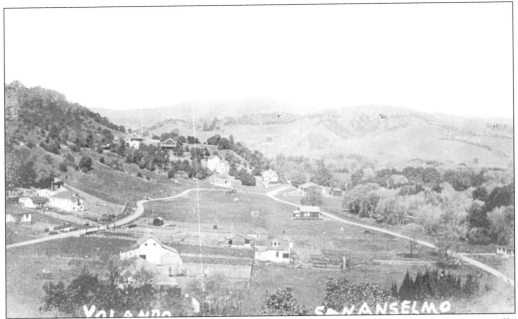

The land encompassing most of the Yolanda and Lansdale neighborhoods was deeded by Manuella Sais, the widow of land grantee Domingo Sais, in 1868 to John H. Saunders, James S. Bush, and Henry McCrea. The area, known as the Bush Tract, remained undeveloped until it was purchased and developed by Hoag & Lansdale in 1905. San Anselmo Avenue is on the right and Elm Avenue is on the left in this 1912 photograph. (Courtesy of Jim Staley.)

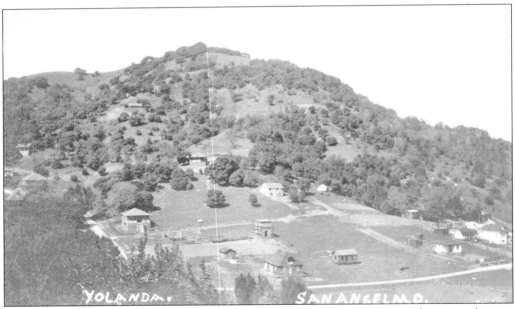

Lots in the Yolanda area were advertised for sale as sites for summer or permanent homes, with many buyers paying their mortgages by renting cottages or camping privileges on their property. Note the hillside cabins and tents. Elm Avenue runs across the lower portion of this 1912 photograph.

Juanita Lawson stops for the camera on muddy Elm Avenue in 1910. In the background is San Anselmo Second Presbyterian Church, which was dedicated in 1908. The church building was used in the 1970s as a recording studio by Marin County's own rock band, Sons of Champlin.

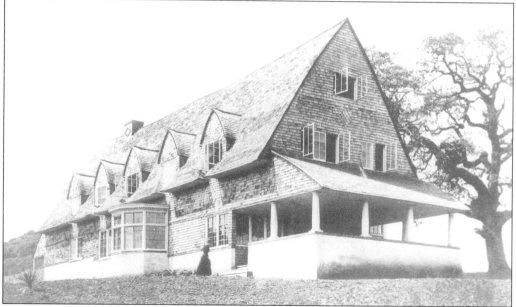

This house, at 96 Park Drive, was designed by the noted architectural firm of Coxhead & Coxhead in 1892 for the Carrigan family. It was originally situated on 23 acres of open grassland. The long, rectangular residence has a sharply pitched roof with five bowed dormers on the second floor. The living room and dining room are open floor plans, partitioned by removable redwood panels. The walls are paneled with heart redwood in three-foot-wide panels. The five upstairs bedrooms face Mount Tamalpais.

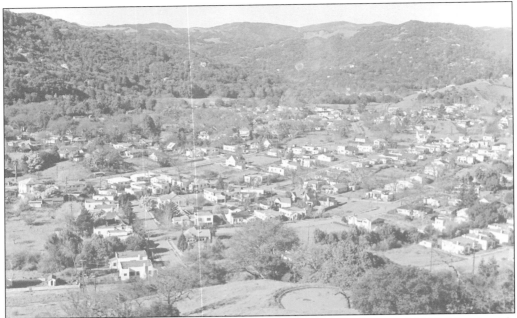

This is a view of Morningside Court from the area of Indian Rock around 1940. Morningside Court was first developed in 1924 by the Doherty Company. Homes were designed with artistic features, and grounds were laid out with lawns and shrubs planted.

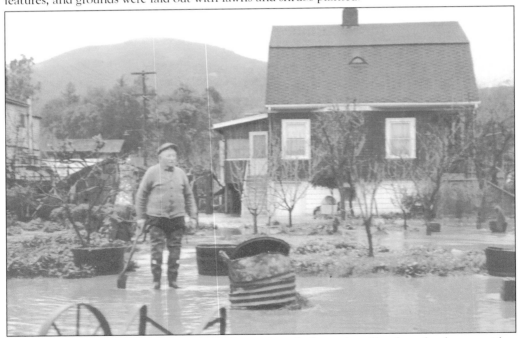

Charles and Emily Pizochero, natives of Italy, purchased a large plot of land one lot deep on either side of Magnolia Avenue from the creek to Cedar Avenue from James and Mary Tunstead in 1900. The Pizocheros subdivided Magnolia Tract in 1904, retaining a large lot in what became the downtown area. Charles Pizochero is seen here surveying his flooded garden in 1943.

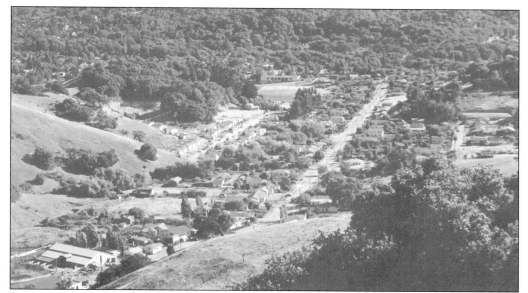

In 1912, a syndicate of investors purchased the Short Ranch and subdivided the large acreage. Subdivision Two included San Francisco Boulevard—in the center of this 1947 photograph—and the surrounding streets. Lots were listed at $500 and up with easy terms. Short Ranch remained rural for many years, with cows grazing the rolling hills at the dairies of the Spagnoli and Sorich families, until after World War II, when an influx of new residents spurred the construction of more homes.

These are the first homes built in the Hawthorne Hills subdivision on Suffield Avenue. The ranch land of Alonzo Traxler was purchased by Albert E. Kent in 1891 and was subdivided by Kent's grandson Thomas Kent and Thomas J. Minto in the early 1920s. (Courtesy of the Anne T. Kent California Room, Marin County Free Library.)

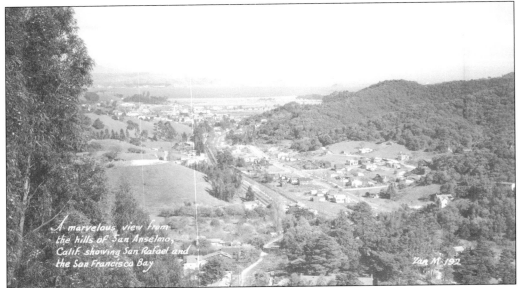

A marvelous view from the hills of San Anselmo, Calif. showing San Rafael and the San Francisco Bay

San Rafael Heights (right), the southeast corner of San Anselmo bordering San Rafael, was subdivided in 1908. Lots up to two acres were offered for sale from $550 to $1500. Restrictions, common at the time, forbade the building of any grocery, saloon, resort, or livery stable on the lots. This photograph was taken in the 1940s.

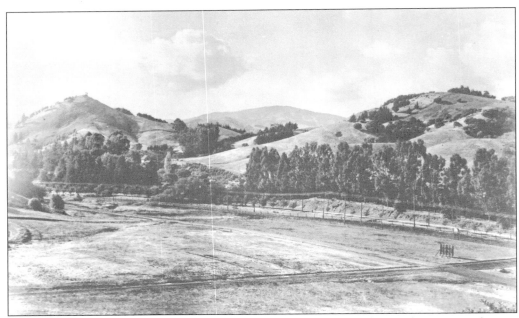

Ross Valley Drive runs across the foreground of this 1909 photograph. Development on the east side of Red Hill started with Sequoia Park, the former Tompkins property, in 1912. The Doherty Company planted 1,500 fruit and shade trees in the new subdivision. Hilldale Park, a former cow pasture to the east, was developed in 1947 by Leach Realty. The first homes on Hilldale Drive sold for $9,700.

Most homes built in San Anselmo in the early years, when many San Francisco residents made San Anselmo their permanent residence, were modest bungalows. They were often built by local developers or contractors without architects' plans. This typical home was in Sequoia Park, which was subdivided from the Tompkins estate in 1912.

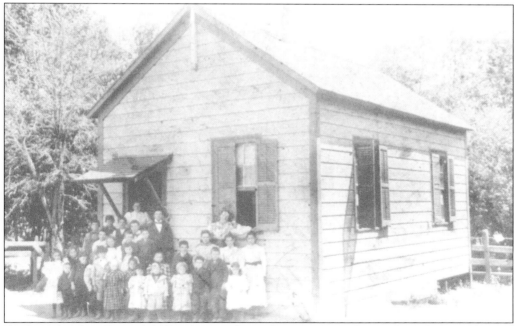

Fairfax School, on Butterfield Road, opened in 1876 to accommodate students from Fairfax and northwestern San Anselmo. It was the first school within the current boundaries of San Anselmo. It was replaced by a larger schoolhouse in 1898. (Courtesy of the Fairfax Historical Society.)

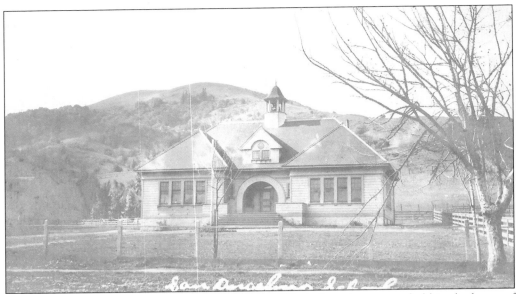

The San Anselmo School District was formed in 1893. At first classes were held in the home of Alexander Bouick, the groundskeeper for the San Francisco Theological Seminary. A school site was purchased in the block bounded by Ross, Sunnyside, Woodland, and Kensington Avenues, and a schoolhouse was completed in 1898. It opened with 48 students and one teacher.

This November 1907 portrait of the students and teachers at San Anselmo School shows how much the school-age population grew when refugees from the 1906 San Francisco earthquake made San Anselmo their permanent home. The little schoolhouse was bursting at the seams.

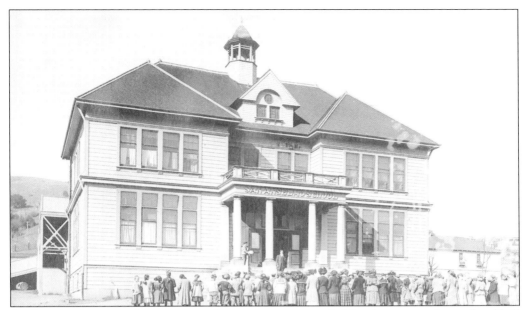

As the school-age population grew and more space was needed for classrooms, the roof and bell tower of San Anselmo School were raised, and a second story was added in 1907. When a school opened at Lansdale in 1908, the San Anselmo School became known simply as Main School.

Wade Franklin Thomas, standing on the left, was the principal of Main School as well as the teacher of this seventh- and eighth-grade class in 1908. He became superintendent of the Confederated School District when it was formed in 1923. Martha Clute, with her arm draped over the railing, later remembered Thomas as a fair teacher, a tireless administrator, and an advocate of physical education for both boys and girls. He was a leading educator and citizen for many years.

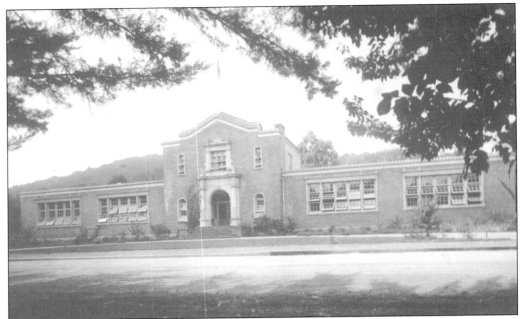

This handsome redbrick school replaced the wooden schoolhouse. Completed in 1922, the new school had eight classrooms, one for each grade, with a kindergarten room upstairs. The building was arranged in a U-shape with covered walkways around a courtyard. In 1946, the school was declared unsafe in the event of an earthquake and was demolished. A new school was built and renamed Wade Thomas School in honor of the longtime superintendent, who died shortly before the school was built. (Courtesy of the Marin History Museum.)

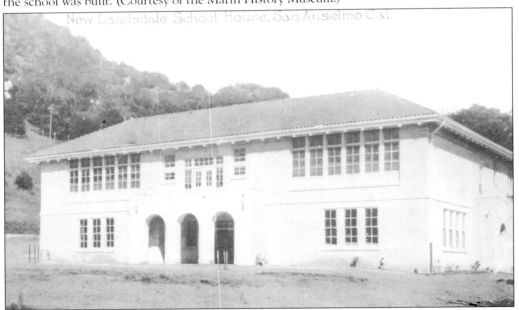

In 1908, Lansdale School opened to serve the growing population at San Anselmo's western edge. It was located at Elm and San Anselmo Avenues. It is seen here after it was rebuilt in 1915. The school was later renamed Yolansdale and closed in 1978.

Red Hill School opened in 1928, with Ida Adams serving as the first principal. She was succeeded by Isabel Cook in 1940. When Cook died, the school was renamed in her honor. The school closed in 1975, and the building was purchased by the Town of San Anselmo.

St. Anselm School opened in 1924. The Sisters of Loretto provided the instruction until 1935, when they were replaced by the Sisters of the Holy Names. In 1981, lay teachers were hired. This photograph shows the fifth- and sixth-grade class of 1928.

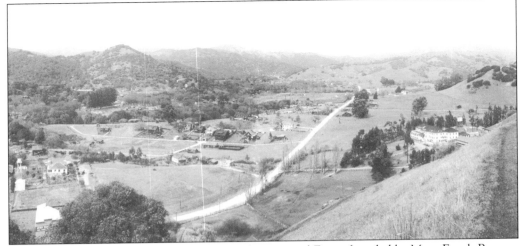

In 1898, the San Francisco Presbyterian Orphanage and Farm, founded by Mary Frank Browne and originally located in San Rafael, purchased 20 acres of the Short Ranch for the construction of a new home for orphaned children. It opened in 1900 with 135 orphans. The main building, on the right in this 1918 photograph, was destroyed by fire in 1922 and rebuilt. The orphanage was renamed Sunny Hills in 1931.

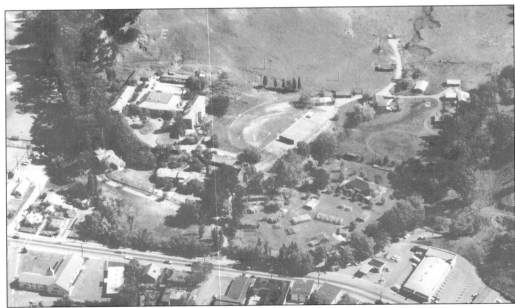

Shipping magnate Robert Dollar of San Rafael donated 42.6 acres to the Presbyterian Orphanage in 1920 to start a dairy and a vegetable garden. In 1937, a farm manager was hired, and cows, pigs, rabbits, and vegetables were raised. This aerial photograph of Sunny Hills was taken in the late 1950s. The farm ceased operation in 1963, and Red Hill Shopping Center was developed there.

Leslie Nuttall (left), a former resident at Sunny Hills Orphanage, feeds one of the dairy cows on the farm at Sunny Hills while two young orphans look on in 1949. The Rotary Club of San Anselmo donated materials, cash, and labor to construct a calf barn in 1955; the group also donated a baby steer. (Courtesy of San Francisco History Center, San Francisco Public Library.)

America's favorite pastime, baseball, had many fans in San Anselmo. This photograph was taken about 1910 at one of several ball fields in the downtown area. In the 1920s and 1930s, more than 1,000 people flocked to Recreation Park (now Memorial Park) on Sunday afternoons to watch the local semiprofessional teams play.

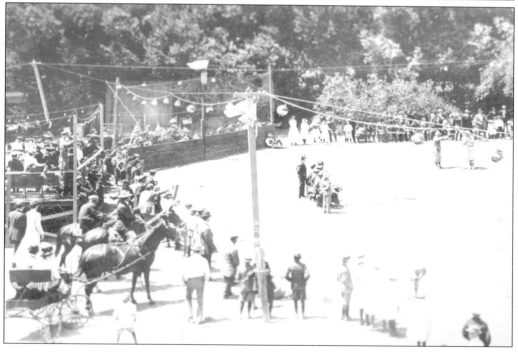

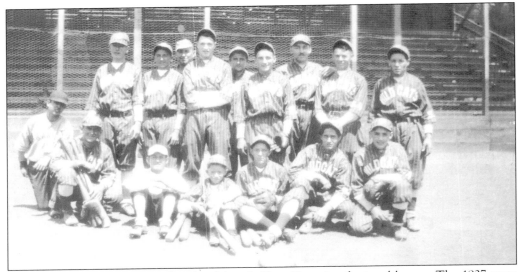

The San Anselmo Wildcats played in Marin's Class C semiprofessional league. The 1927 team included, from left to right, (first row) Phil Freitas, Peter Testa, George Sousa, Al Massara, Oliver Granucci, unidentified, and Frank Sousa; (second row) Bill Franchini, Marco Massara, Ralph Asay, Roy Franchini, Al Colombo, Bill Sousa, J. Pallavicini, Charles Bogni, and unidentified.

Basketball was popular in the schools with both girls and boys, including with this young 1918 team. The girls at Main School sold candy in 1909 to earn money for the construction of a basketball court.

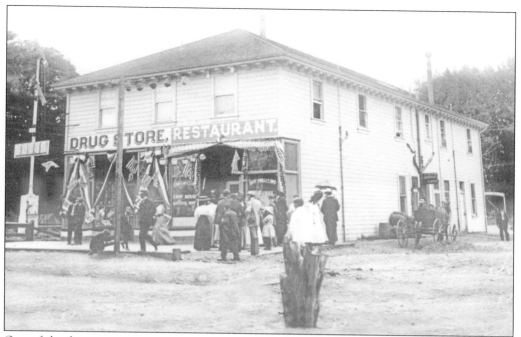

One of the first restaurants in town was at the corner of Tunstead and San Anselmo Avenues next to Hund's drugstore. It was called the San Anselmo Chop House and Oyster Depot. In this 1909 photograph, it appears to have been a popular place for families.

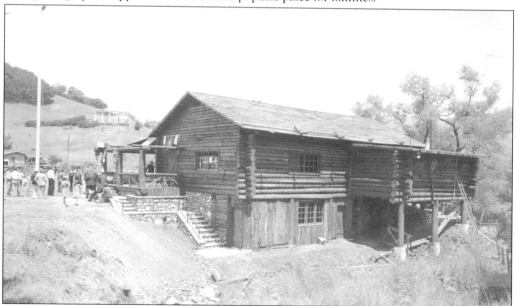

American Legion Post No. 179 was organized in 1927. In 1933, the legionnaires began construction of this log cabin, which was used by the Boy Scouts and as a meeting place for the post. It was constructed mostly with materials and labor donated by the legionnaires. The furniture, fireplace, and chimney were the work of local San Anselmo residents. This is a view from the rear shortly after construction. (Courtesy of the Jack Mason Museum.)

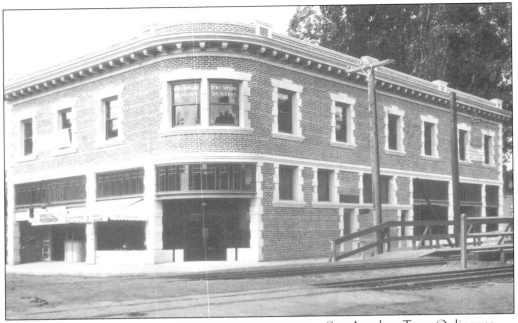

THE

STRAND

SAN ANSELMO'S NEW AND BEAUTIFUL MOTION PICTURE THEATRE

OPENS WEDNESDAY
APRIL 20th

PRESENTING

BEBE DANIELS

IN HER LATEST SCREEN SUCCESS

"DUCKS and DRAKES"

ADDED ATTRACTIONS WILL INCLUDE
PRIZMA NATURAL COLOR PICTURES — A 2-REEL COMEDY
NEWS TOPICS

Above Program - 2 Days Only Apr. 20-21

Friday April 22
LIONEL BARRYMORE in "The Master Mind"

Saturday April 23
CONSTANCE BINNEY in "Something Different"

WATCH FOR FURTHER ANNOUNCEMENTS

San Anselmo Town Ordinance No. 81, established in March 1911, permitted the operation of a movie theater in town, and one opened shortly after in the newly completed Cheda Building. The banner at the far left advertises the movie *Special Messenger*. Admission was 5¢. There was a little ice cream parlor adjacent to the theater.

In 1921, the San Anselmo Theatre in the Cheda Building was remodeled and reopened under new management as the Strand. Old-timers recalled that light from the upstairs projection room, with its big mercury arc lamp, reflected off the surrounding buildings when the projector was running. The Strand closed when the Tamalpais Theatre opened on Sir Francis Drake Boulevard in 1924.

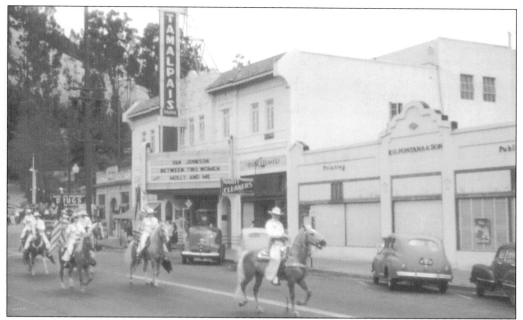

In February 1924, the big news in town was the opening of the Tamalpais Theatre. It could seat 1,000 people and boasted a $25,000 organ. Opening night featured a concert, followed by the *The Humming Bird*, starring Gloria Swanson. Admission was 30¢ for orchestra seats, 40¢ for the loge, and 10¢ for children. The theater closed in 1989 after the Loma Prieta earthquake, and the theater section of the building was razed. The theater is seen here in July 1945 as a horse parade passes in front.

These Fourth of July revelers—costumed clowns, bumpkins, and what have you—were called "The Horribles" and added a touch of merriment to the celebrations. When it came to costumes and creativity, good humor ruled. Red Hill rises in the background of this 1909 photograph.

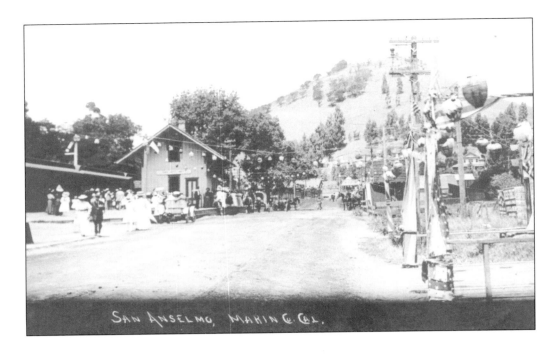

SAN ANSELMO, MARIN CO. CAL.

The Fourth of July was a major celebration in San Anselmo in the early 1900s. The streets were decorated with flags and banners. The parade featured floats of all kinds, clowns, marching bands, and musicians, and then the queen of the parade, the Goddess of Liberty, would ride past in her regal glory. Festivities also included a baseball game, foot and horse races, a band concert, a literary recitation, and fireworks. The day would end with a dance at Pioneer Hall on Ross Avenue.

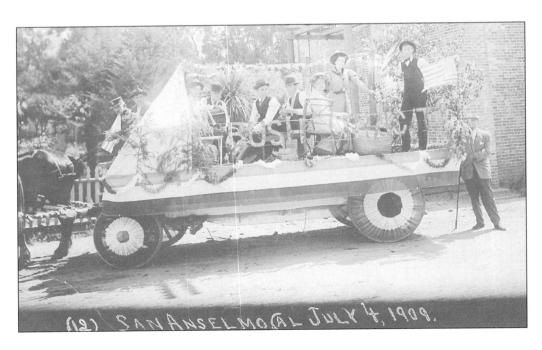

(12) SAN ANSELMO CAL JULY 4, 1909.

Navy Day was celebrated in San Anselmo in a big way on October 10, 1928. There was a colorful parade with a reviewing stand at town hall. Three white Navy planes did thrilling maneuvers overhead. A barbecue lunch was served to the enlisted men at the Log Cabin, and a baseball game followed in the afternoon, with the San Anselmo men beating the sailors 6-0.

San Anselmo continues the tradition of parades and celebrations. Country Fair Day, which includes a parade on San Anselmo Avenue, has been held almost every year since 1970. The town-sponsored community event includes a pancake breakfast at the fire station, music, and booths sponsored by local groups. These parade participants celebrate San Anselmo's 90th birthday in 1997.

DISCOVER THOUSANDS OF LOCAL HISTORY BOOKS
FEATURING MILLIONS OF VINTAGE IMAGES

Arcadia Publishing, the leading local history publisher in the United States, is committed to making history accessible and meaningful through publishing books that celebrate and preserve the heritage of America's people and places.

Find more books like this at
www.arcadiapublishing.com

Search for your hometown history, your old stomping grounds, and even your favorite sports team.

Consistent with our mission to preserve history on a local level, this book was printed in South Carolina on American-made paper and manufactured entirely in the United States. Products carrying the accredited Forest Stewardship Council (FSC) label are printed on 100 percent FSC-certified paper.

MADE IN THE
 USA